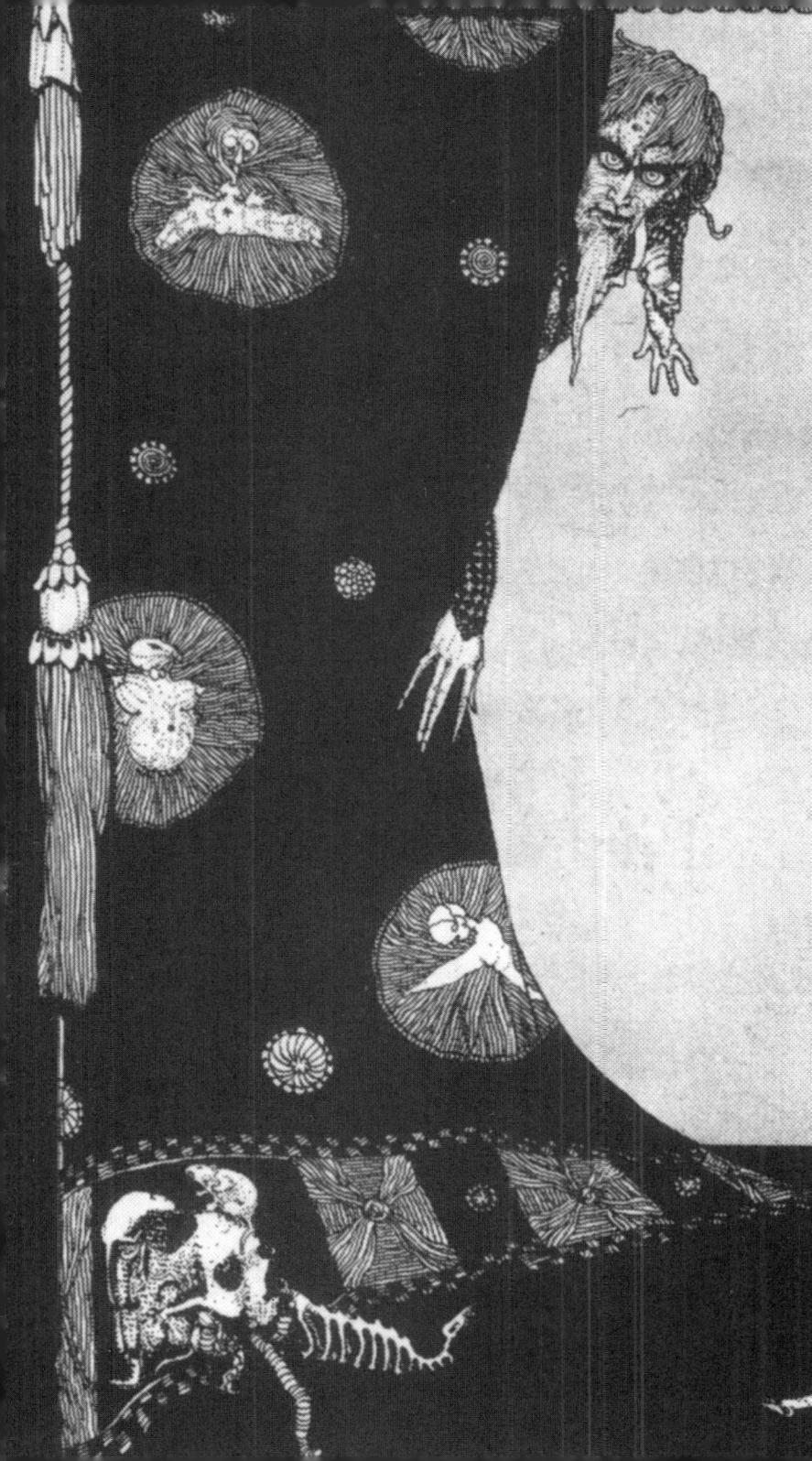

NIGHTMARES IN DECAY

THE EDGAR ALLAN POE ILLUSTRATIONS

harry clarke

CREATION ONEIROS

NIGHTMARES IN DECAY

The Edgar Allan Poe Illustrations
Harry Clarke
ISBN 978-1-902197-30-2
Published by Creation Oneiros 2010
www.creationbooks.com
Copyright © Creation Oneiros 2010
Introduction copyright © D. M. Mitchell 2009
All world rights reserved
Design by Tears Corporation

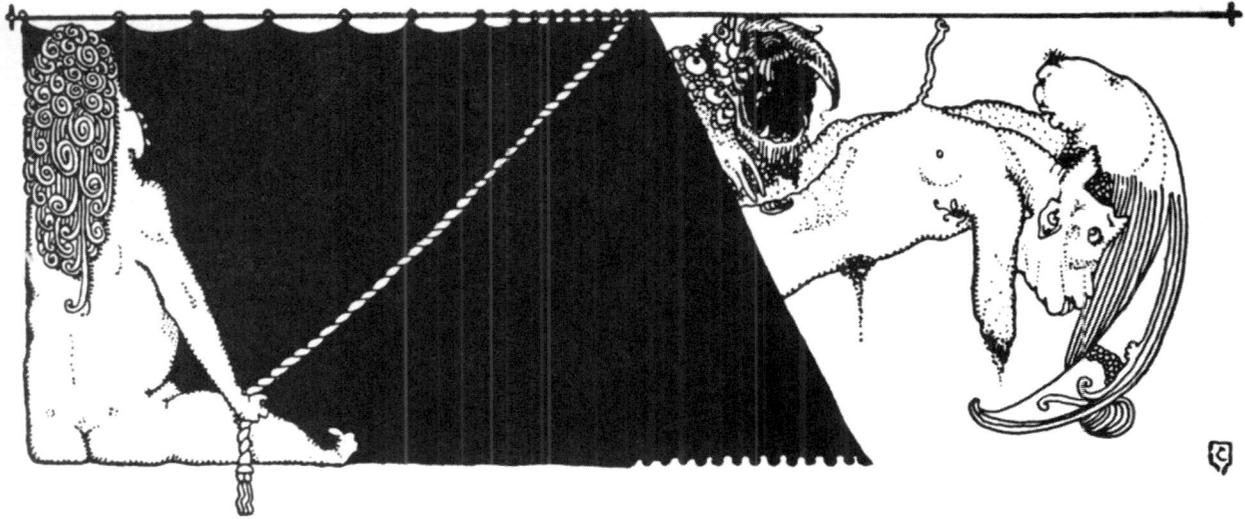

CONTENTS

iii) The colour illustrations

THE TELL-TALE HEART
("He shrieked once – once only")

METZENGERSTEIN
("An attachment which seemed to attain new strength")

LIGEIA
("And now slowly opened *the eyes* of the figure which stood before me")

THE MYSTERY OF MARIE ROGÊT
("His rooms soon became notorious through the charms of the sprightly *grisette*")

THE COLLOQUY OF MONOS AND UNA
("In death we have learned the propensity of man to define the indefinable")

THE MAN OF THE CROWD
("It was the most noisome quarter of London")

THE FALL OF THE HOUSE OF USHER
("Say, rather, the rending of her coffin")

MS FOUND IN A BOTTLE
("The colossal waters rear their heads above us like demons of the deep")

iv) Tailpieces

INTRODUCTION

D. M. Mitchell

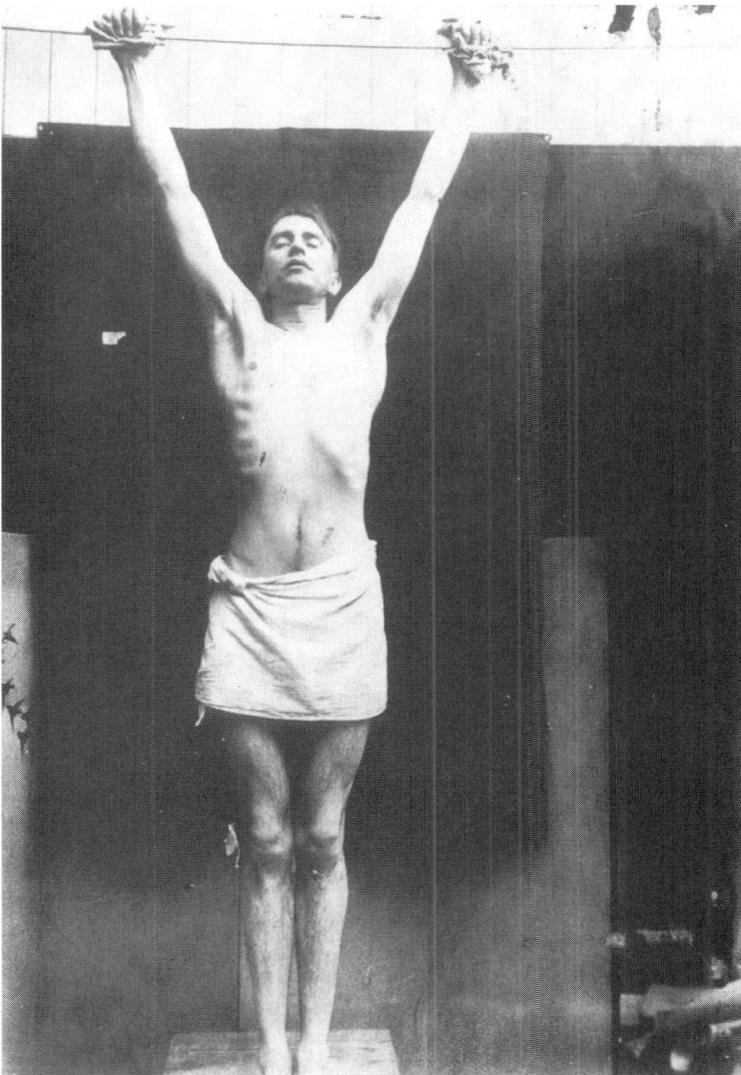

LIFE

Harry Clarke, born in Dublin 1889 is probably the most unjustly neglected of twentieth century artists. Very few people, if asked, would recognise his name, yet in his forty-one years, Clarke illustrated six major books over a fifteen year period (including Poe's 'Tales of Mystery and Imagination' and Goethe's 'Faust') and created, with his studio, one hundred and thirty stained glass windows, probably the best of which is the controversial 'Geneva Window'.

His father Joshua Clarke was a church decorator and manufacturer of art, and had a successful business based at 33 North Frederick Street. He was a master craftsman who produced, among other things, stained glass windows, and Clarke naturally followed in his footsteps, apprenticed to him at the age of seventeen. Although Clarke's work nowadays is known (if at all) through his drawings, it was as a stained glass designer and artisan that he concentrated most of his efforts. Aside from studying in his father's studio and the Dublin Metropolitan School of Art, he spent a short time learning his craft in at the South Kensington School of Design in London.

In 1907 he discovered the works of Aubrey Beardsley at the Irish International Exhibition, and these proved an obvious influence on him stylistically, although the frequent comparisons between the two men's drawings are definitely overstated.

1909 saw Clarke executing sporadic graphic commissions and concentrating on the more challenging aspects of stained glass production. That year he was also awarded a Scholarship in Stained Glass and began his study under A.E. Child at the Dublin Art School.

His work "The Consecration of St. Mel, Bishop of Longford, by St. Patrick" won a Gold Medal in 1910. It was the first work he submitted to the Board of Education National Competition. Continuing with his scholarship education, he won a Gold Medal for stained glass in the National Competition three times. In 1913, he won the first prize in the Art Industries Exhibition at the RDS for his panel "The Baptism of St Patrick".

When he had finished his course, he relocated to London and began illustrating books, beginning with two major efforts that have never seen print: "The Rape of the Lock" by Alexander Pope and Coleridge's "Rime of the Ancient Mariner". He also won a travelling scholarship which helped him to spend some months in Paris and other parts of France.

The Coleridge book had been intended as his first published work, but whilst in London in 1913 (and unsuccessfully looking for illustration work) he was 'discovered' by George Harrap, who recognised his outstanding talent and hired him to create illustrations for a collection of Andersen's Fairy Tales. Clarke postponed work on "Ancient Mariner" and started this new commission at once. This book was finally printed in 1916. Later that year the "Ancient Mariner" book was completely abandoned after most of the drawings were destroyed in "The 1916 Easter Rising" in Dublin. By this time Clarke had also done preliminary work on one of his most famous series: "Tales of Mystery and Imagination" by Edgar Allan Poe.

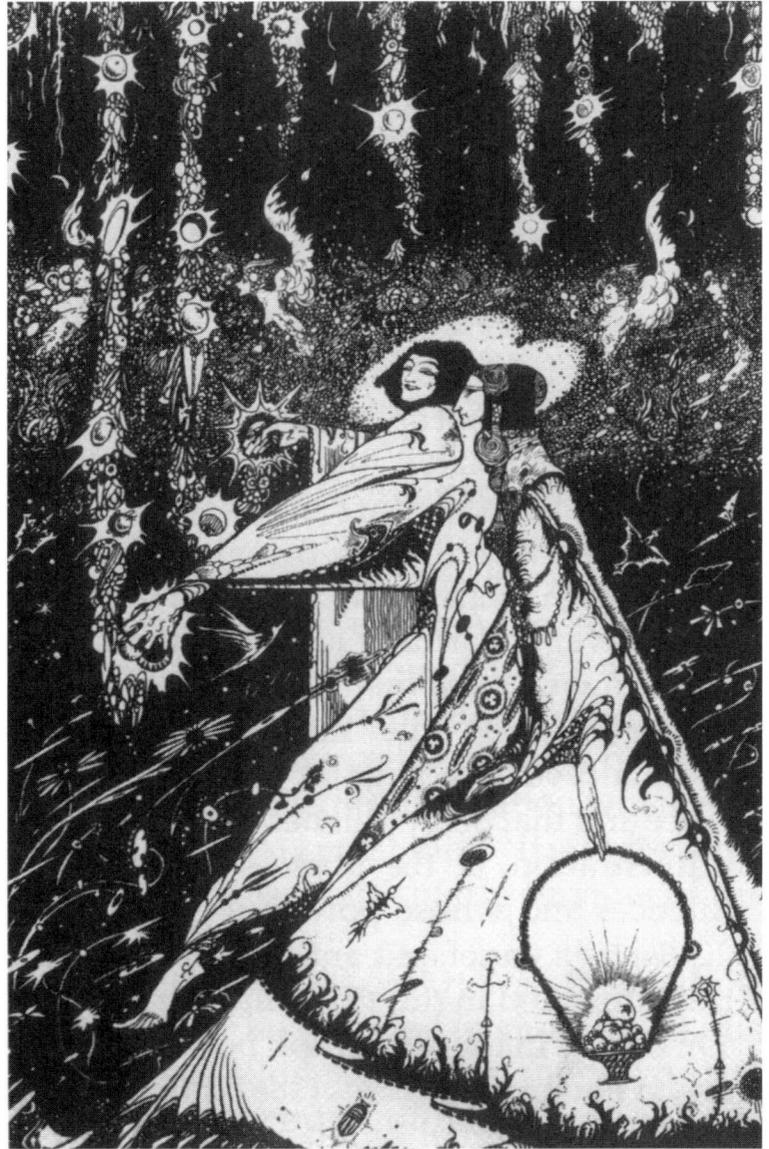

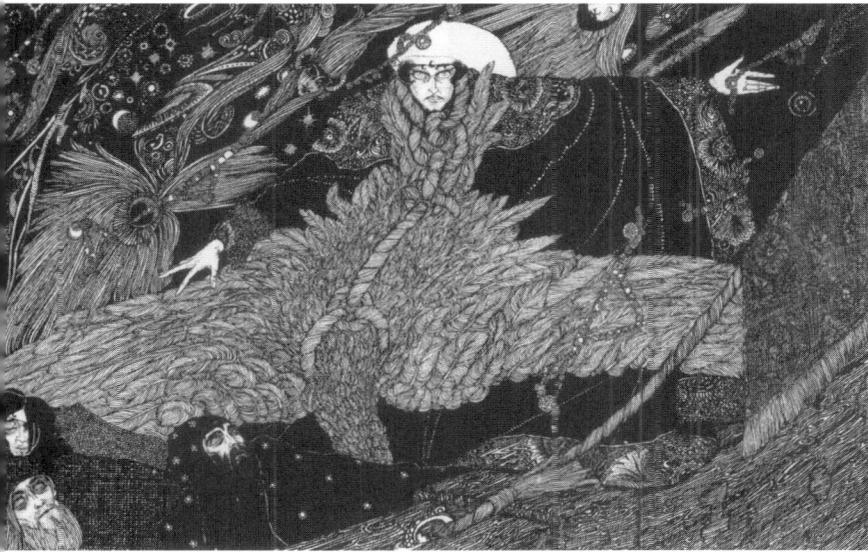

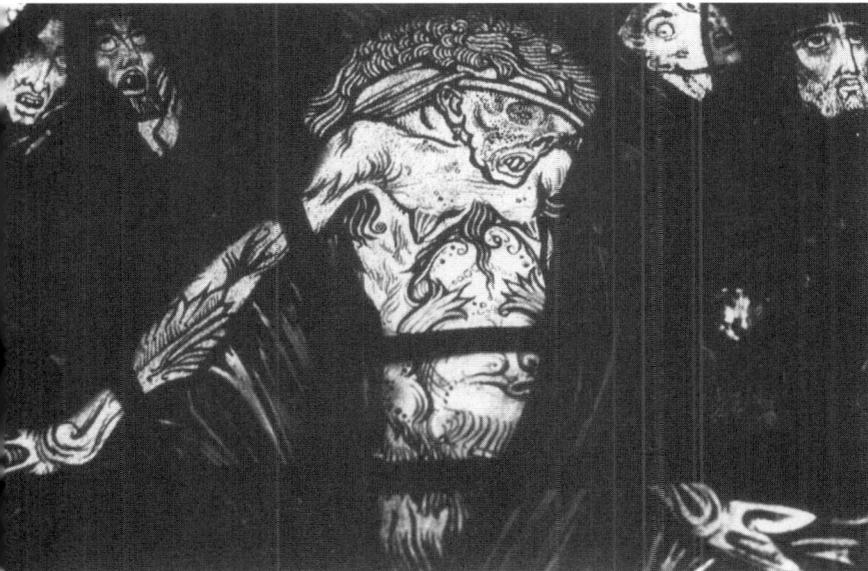

In the autumn of 1914 Clarke returned to Dublin and married Margaret Crilly, also an artist, and around the same time he met Thomas Bodkin, a barrister with a knowledge of art, who became his close friend and most supportive critic and who later became director of the National Gallery in Dublin.

After their marriage Harry and Margaret Clarke were given a flat in the family house in North Frederick Street by Joshua Clarke, who moved out to Shankill. Harry Clarke lived in North Frederick Street for some years, and his studio continued to be based there. He and Margaret would eventually move to Merrion Avenue.

Although his illustrating skills brought him money, his heart was always primarily in his stained glass work, which he continued to enter into competitions. In 1914 his panel "The Baptism of St. Patrick" was exhibited in the Louvre. Clarke also designed fabrics and handkerchiefs, boxes and lanterns, but mostly he designed windows for many Irish churches, institutions and private houses, among them St Mary's Haddington Road, Carlow Cathedral, the Catholic church in Phibsboro, the house of the Jacobs family in Dublin, and Lawrence Waldron's house in Ballybrack.

The drawings for "Tales of Mystery and Imagination" were completed in 1918 and the book went through numerous editions by Harrap, including an enlarged edition in 1923 with eight additional colour plates added. Other books followed: "Ireland's Memorial Records 1914-1918", being the names of Irishmen who fell in the Great War; "The Year's at the Spring"; "Perrault's Fairy Tales"; Goethe's "Faust"; and "Selected Poems of Algernon Charles Swinburne" in 1928.

He made many miniature stained glass panels on individual themes, for instance illustrations to Flaubert's "La Légende de St Julien", one of Bluebeard, and a scene from "A Midsummer's Night's Dream" (depicting Titania and Bottom). In 1925, the Irish government proposed that Harry Clarke should design and make a window to be presented to the League of Nations for the International Labour Building in Geneva, a window which has ever since been known as "The Geneva Window". He initially deferred work on this due to problems with an eye condition.

During the last few years of his life, Clarke was plagued by ill-health. In 1926 he'd had a serious, almost fatal, bicycle accident. He'd recovered but was left with a legacy of severe headaches. His infirmity was aggravated by the ferocious working pace he set himself in creating glass and book illustrations and struggling to trying to keep afloat his father's studio, which he and his brother Walter ran after the death of their father in 1921. In 1930, shortly before his death, Clarke split the stained glass business off from the decorating business, which he then closed. His brother died in July but Clarke increased the pace of his work, despite his infirmity, to inspire confidence in the new studio.

The Irish Government had at this stage bought the Geneva Window from Clarke but it had not been presented to the League of Nations. The Government was undecided as to whether it was "suitable" or not. Harry Clarke died before a decision was reached, on 6 January 1931. He died at Coire, in Switzerland, where he is buried. More than a year later the Government had still not decided what to do with the window; Margaret Clarke, weary of the indecision and irritated by criticism by conservative politicians,

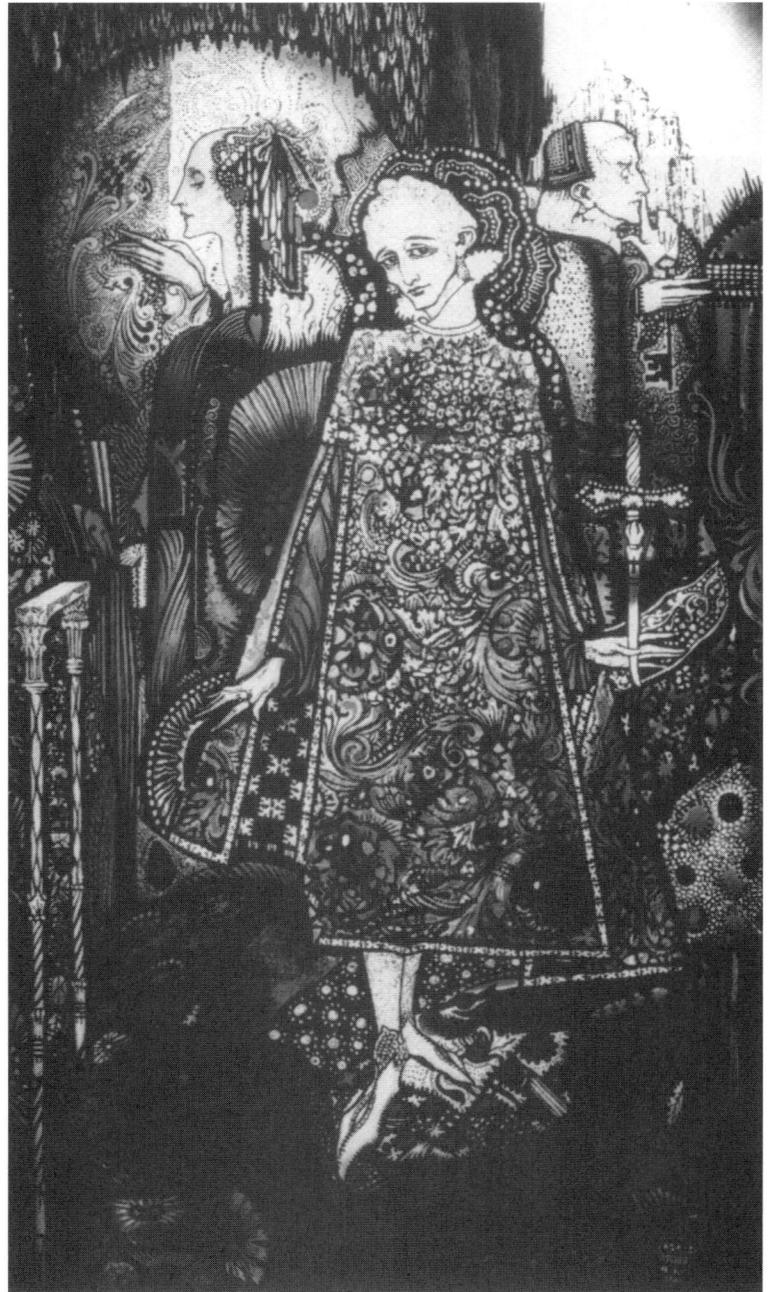

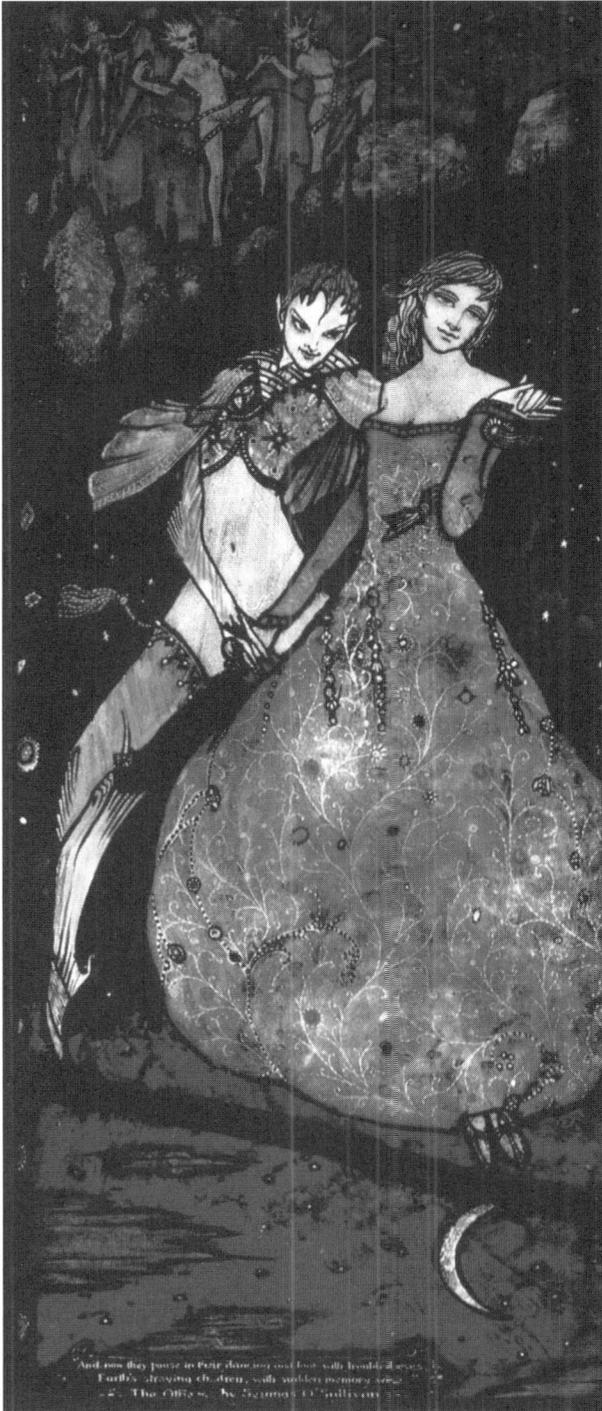

"And now they pause in their dancing and look with trouble eyes / Earth's straying children, with sudden memory wise... / — The Others, by Seumas O'Sullivan"

bought it back from them after its design had been severely criticised by a reviewer in "The Catholic Bulletin". The Geneva Window, described by Thomas Bodkin as "the loveliest thing ever made by an Irishman", finally found its way to the United States. It is still there.

ART

The most obvious influence on Clarke's black and white illustrations is, of course, Aubrey Beardsley, brilliant innovator and neuropath, who cast his long consumptive shadow over a whole generation of artists caught stranded between the receding tides of Symbolism and Decadence, and the frenetic onslaught of the non-representational art (and anti-art) movements that followed; Cubism, Futurism, Dada et al. All of these were polemic in the extreme and none would have time for Clarke's finesse. By the time Surrealism arrived on the scene, the only movement at that time likely to appreciate Clarke, he was already relegated to obscurity.

The predictable comparison of Clarke to Beardsley is, however, an odious one. Although there are obvious technical similarities (particularly in Beardsley's baroque and notoriously complex drawings for "The Rape Of The Lock" which prefigured the suffocating use of large areas of blacked-in space in Clarke's illustrations for Poe), Clarke also drew on many other sources for inspiration. And there are marked differences between the two men's work that are probably more relevant than the similarities.

Beardsley's work achieved much of its impact through confrontational, 'scandalous' subject matter, overtly ambiguous eroticism, carefully planned and deliberate. Most of what ended up in a Beardsley drawing was contrived and mannered, the product of reason rather than delirious vision. Clarke's compositions, on the other hand, almost always had a darker, introverted feel, and the febrile arrangement of figures and landscapes were as if spewed out from the depths of a tortured soul.

There is eroticism to be found in Clarke's

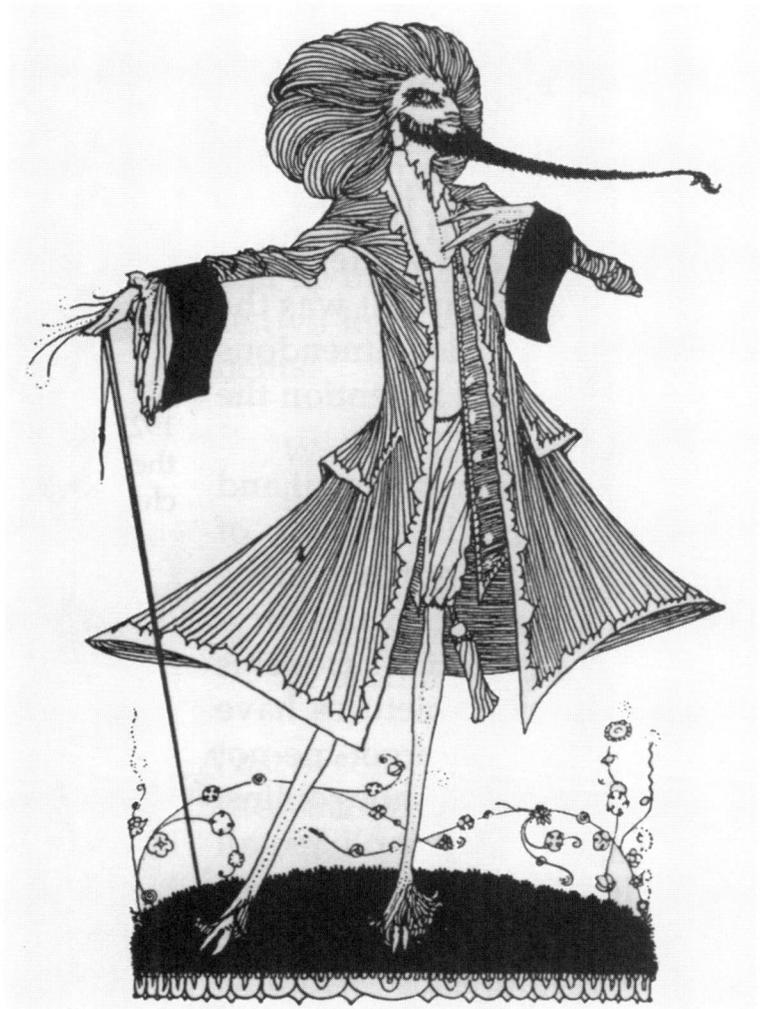

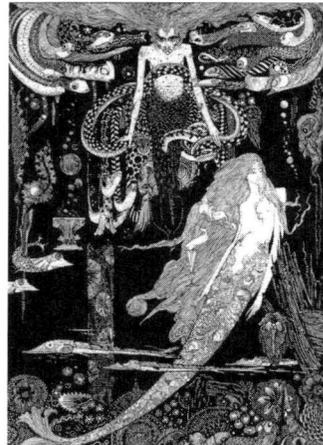

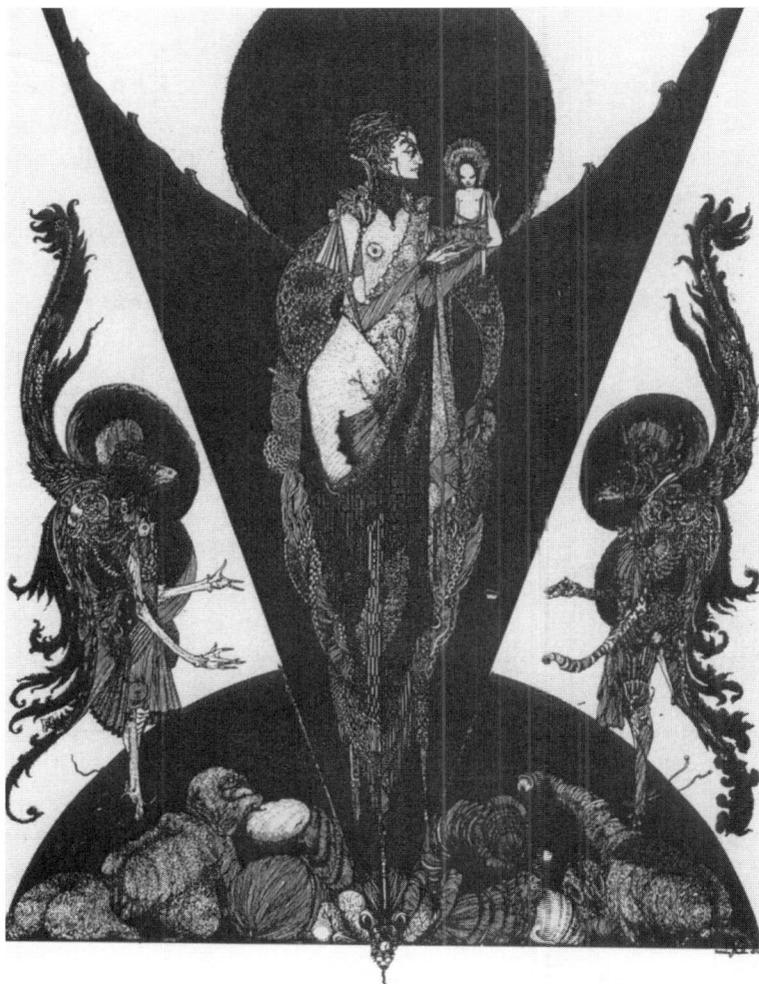

work, as in Beardsley's, but it is not an outward-looking extroverted eroticism, rather an inward-turning form of self-love similar to that possessing the automatic drawings of Austin Osman Spare. Indeed some of the vignettes in Clarke's "Faust" are strongly suggestive of Spare's own smaller works. It's worth noting that in 1925 Spare, Alan Odle, John Austen, and Harry Clarke showed together at the St George's Gallery, and in 1930 at the Godfrey Philips Galleries, so the men were well aware of each others' output.

Clarke's approach to composition in his scenes had far more in common with Sidney Sime and Frank Brangwyn than Beardsley. Clarke was also entranced by the art of Rossetti, Annie French, E.J. Sullivan and Gustave Moreau among others. Often Clarke would borrow a detail from other painters and metamorphose it into something strange and totally his own – for example the distant, highlighted doorway in his illustration for "M Valdemar", lifted straight from Velazquez' "Las Meninas".

Although Harry Clarke never formally belonged to a movement or artistic group there were, as mentioned previously, a considerable number of artists 'post-Beardsley' who in many ways shared a similar spirit to Clarke and drew on similar preoccupations. The fervour and scandals of Decadence had abated, giving way to a gentler form of fantasy and 'orientalism'. Illustrated editions of Fairy Tales become popular 'coffee table' acquisitions; sporting variously the works of Dulac, Nielsen or Rackham. Charles Rennie Mackintosh translated this aesthetic into many media, made publicly available through the new upsurge in the mass-production of art. Other artists, marginally popular at the time and now pretty much forgotten, developed Beardsley's baroque legacy in different directions, but usually

without adding much to the recipe; Jessie Marion King, Peploe, Nicholas Kalmakoff. Clarke's brooding dreamscapes, by contrast, drew on darker wellsprings of inspiration; those supped at by Klimt, Toorop, Kupka and Alfred Kubin, albeit executed in a way far more elegant, concentrated and focused than any of those could manage.

There is a unifying style that links all of Clarke's illustrations, unlike Beardsley's. The latter's oeuvre progressed rapidly from very highly detailed linear drawings (eg "How King Arthur Saw The Questing Beast") through more abstract books such as "Salome" (with their use of flat planes of black and white), to the highly wrought Rococo works for the Savoy and "Under The Hill". Beardsley was a constant experimenter with a restless imagination and became frequently bored with projects on which he was engaged. Clarke on the other hand seemed to find his definitive style from the time of illustrating "The Ancient Mariner" and, although it deepened and flowered, he didn't veer much from it throughout his career.

Although he was very aware of developments in the contemporary art world, his work remained rooted in the traditions of his native culture; in both Celtic myth and legend, and in the iconography of the Catholic Church. The drawings and colour plates for the Andersen book were still very much indebted to Beardsley in terms of background, figure composition and décor. The clothes worn by the characters in the drawings are a grotesque and lurid mixture of historical garb and (then) modern fashion; top hats and canes, patchwork robes and harlequinade, lush oriental jewellery and head-dresses, wigs and hairdos from the court of Louis XVI. The colour washes also show his awareness of, and rapture with, painters such as Rossetti and

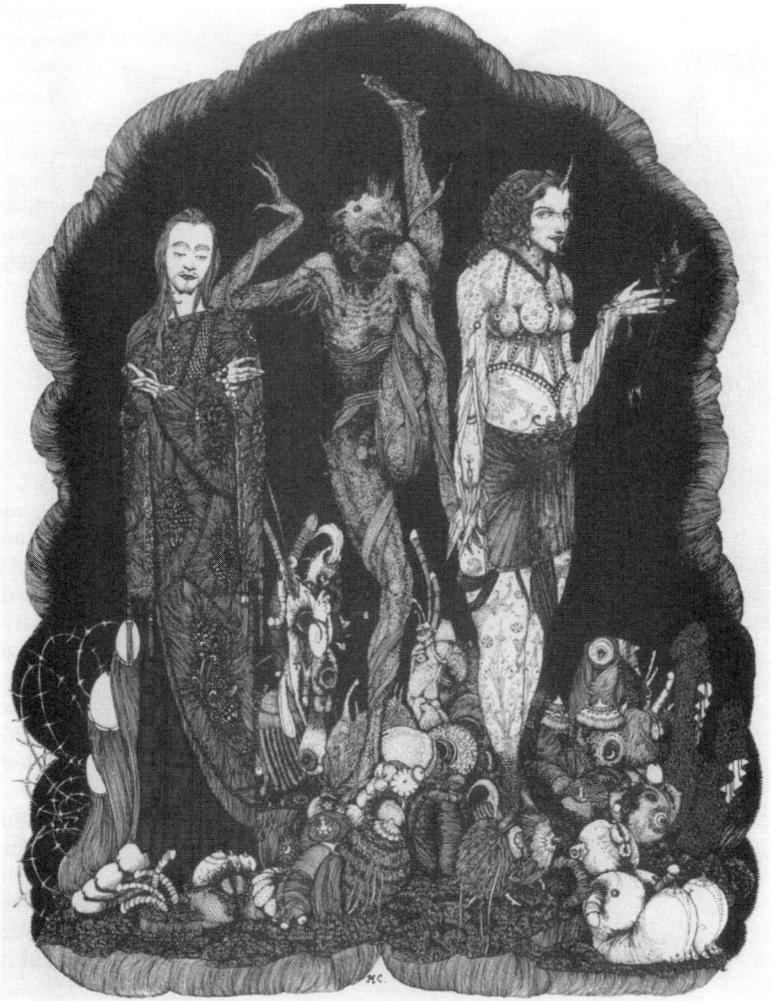

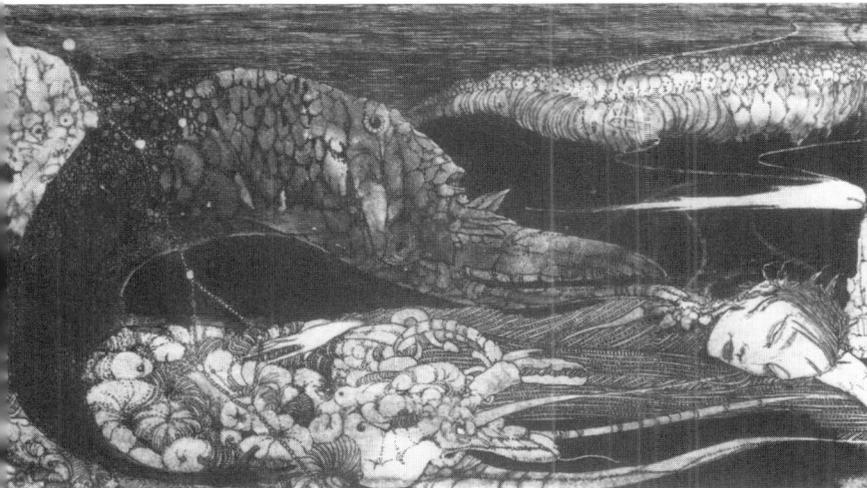

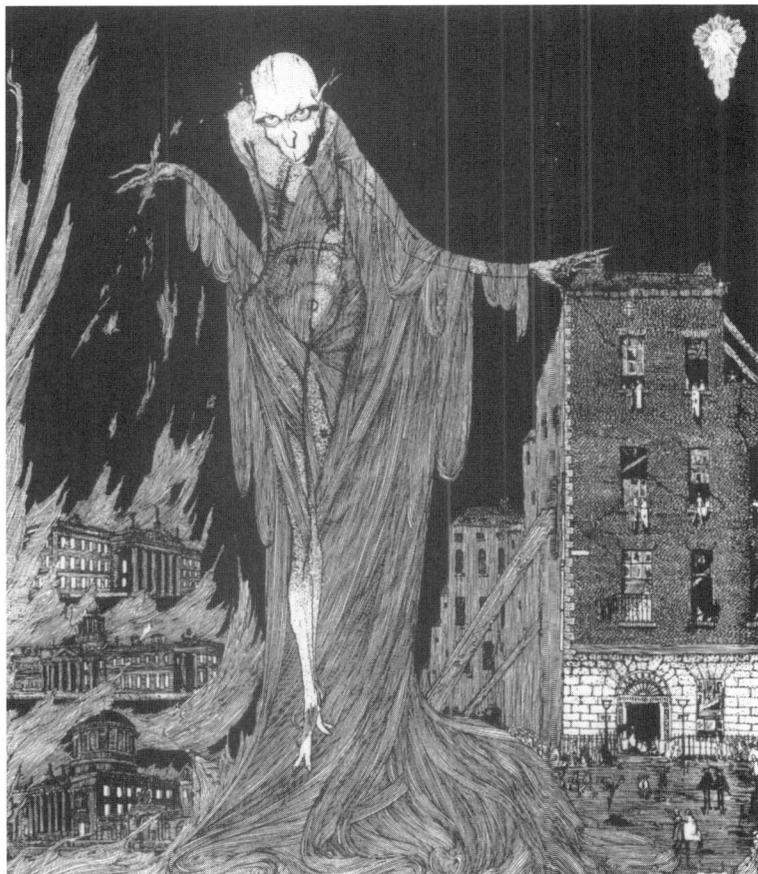

Moreau, the friezes of Brangwyn and in some cases the paintings of Felicien Rops.

His illustrations for Poe marked a departure. Even now they still seem quite shocking and controversial. People close to his family were puzzled as to where the inspiration for many of the contorted, tortured or moribund figures and scenes could have originated. The illumination and levity in his fairy-tale illustrations had been replaced by huge masses of black in which the human characters are often shrouded and in some instances even diminishing into a cavernous darkness. It has been suggested that a similar inclination in Beardsley's art paralleled his gradual succumbing to tuberculosis. It's tempting to see something of the same with Clarke. Although most of his material was consciously designed and crafted, more of it seemed to well up from some dark racial unconscious – the dark mind of the Celt. Despite his rigid work ethic, the slow eating away of his sickness must have lent much of the feeling of morbidity to those later drawings.

With "Faust" the morbidity increased, albeit in a subtly different way. His usually meticulous and contained compositions began to fragment and spill out of their bounds into a meta-pictorial space. They had become a delirious swarm of auto-erotic ciphers and glyphs reminiscent of Spare's "Alphabet of Desire". Teratomata and hybrids squirmed around each other sinuously and sensuously in mixed pleasure and torment. Some of the larger panels did still link directly to the Poe illustrations, but even these were somehow abstracted and left suspended in some existential Kierkegaardian void. In places, Clarke's Irish background showed through in the form of equestrian figures and other totemic animals (elongated canines, hares,

13

birds and serpents) twisting on each other in Celtic knots and occasionally reminiscent of the illuminated characters in the Book of Kells. Some of the figures were so bizarre and surreal that they prefigured the 'underground comics' of the psychedelic 1960s and one wonders if the fumes from the noxious chemicals that he would have worked with on a daily basis in his stained glass workshop could have influenced some of these.

Clarke's last book of illustrations, for the "Collected Poems of Charles Algernon Swinburne", revealed a stunning maturity of composition, with more frequent washes and less use of pronounced chiaroscuro. The latent eroticism of his earlier drawings had become more blatant, openly pagan in their celebration of sexuality, particularly female sexuality. The female figures in these drawings were mostly nude or semi-nude, brazen and voluptuous in an ophidian way; the opalescent pseudo-oriental clothing they wear more for ornamentation than concealment. Visions of Hell and Heaven interchanged yet remained constantly carnal, expressions of Blake's "Eternal Delight".

These illustrations, however, met with criticism, crucially from Humbert Wolfe who wrote the introduction to the volume and noted there that Clarke's interpretation of the poems was opposed to his own, (implying, rather pointlessly, that it was incorrect). The writer Æ (George Russell) also opined that Clarke "was less close to Swinburne"; he commented on "the gloom which invests his creations", which was at odds with the vigorous mood of Swinburne's poetry, although he confessed to admiring the imaginative power of the drawings. The dark and gloomy side of Harry Clarke's imagination, when he gave true expression to his own voice, was not always popular.

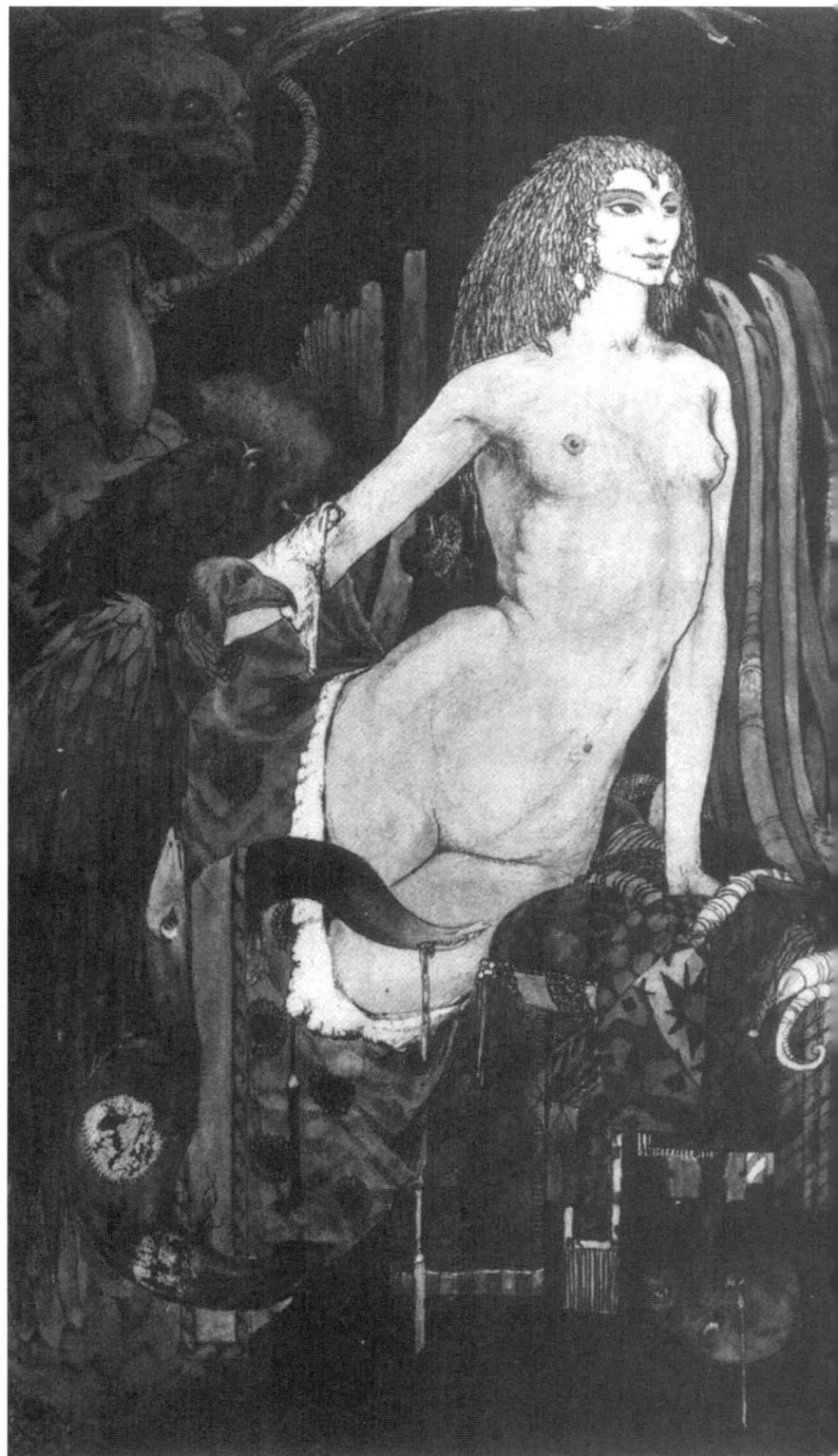

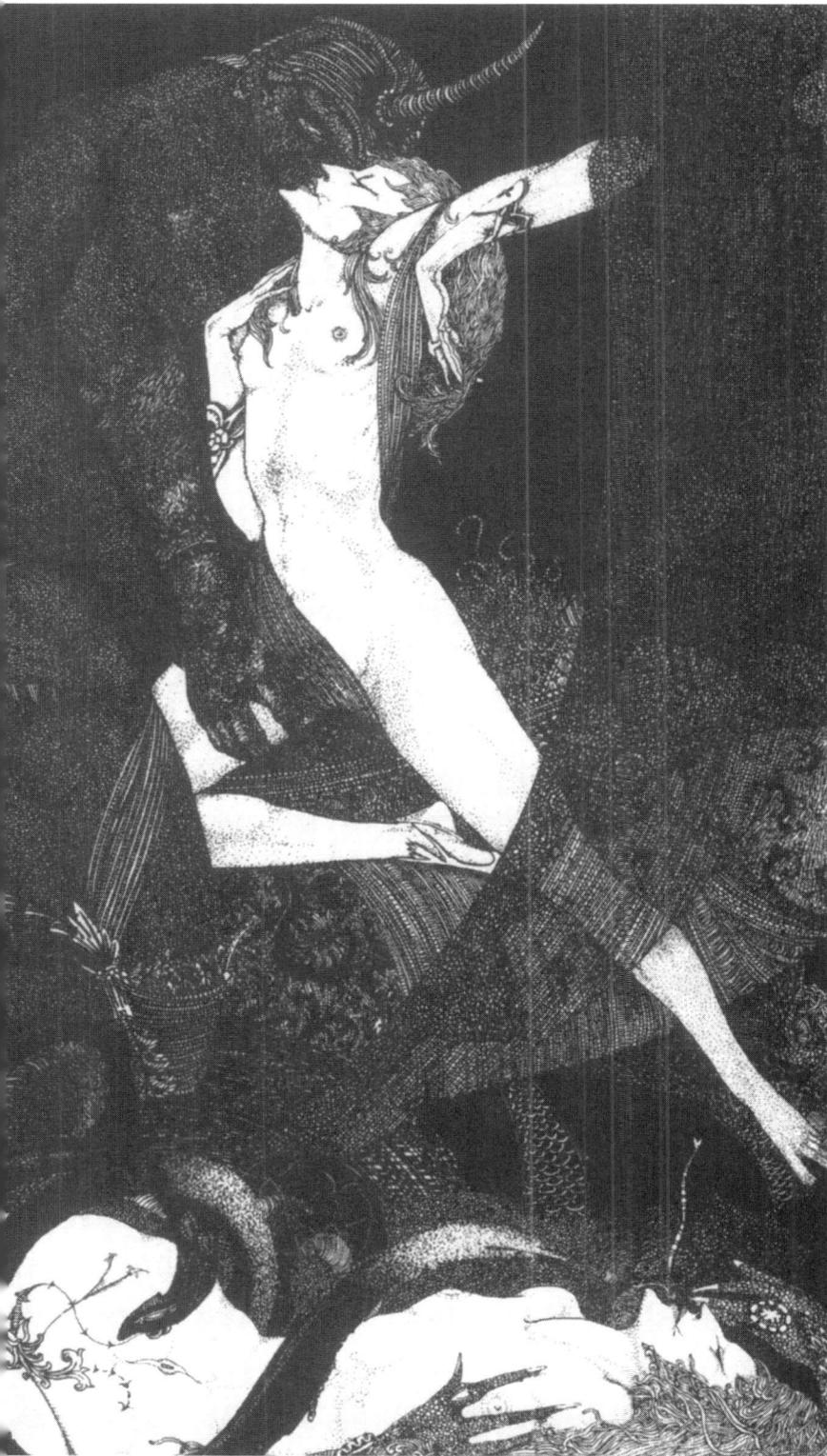

As previously stated, it was always his stained glass work that Clarke considered central to his life. It was the designs he submitted for five stunning windows in the Honan Chapel in Cork, that he would later craft and install there in 1916-17, that first made his reputation. Between 1913 and late 1919, he went on to design and execute more than a dozen windows for war memorials and chapels, as well as many panels for private commissions. These were often interpretations of poems or ballads done in small (7"x12") format. Many people consider his panel "The Eve of St. Agnes" (which illustrated Keats' poem of that name) to be his masterpiece.

In March 1922, Sister Superior Mary of Saint Wilfrid commissioned Harry Clarke to make a large three-light stained glass window, The Coronation of the Blessed Virgin Mary for the convent chapel at the educational training college in Glasgow, of which she was Principal. It was to be in memory of victims of the 1914-1918 war. Such was its success that she commissioned the present magnificent three-light window from Clarke in 1926 to be a further war memorial, the same size as its predecessor.

Stained glass windows traditionally are associated with religious icons, but Clarke spent much of his time on secular and literary designs. In 1925 the Irish Free State agreed to present a stained glass window to the International Labour Building at the League of Nations in Geneva. Clarke, who already had an international reputation, was eventually commissioned and a scheme was evolved for an eight-panelled window of scenes from contemporary Irish literature. The authors chosen were Shaw, Yeats, Lady Gregory, Synge, Joyce, AE, Padraic Colum, Seamus O'Sullivan, James Stephers, O'Casey, George Fitzmaurice, Lennox Robinson, Liam O'Flaherty

and Seamus O'Kelly. Despite the fact that President Cosgrave and other ministers were involved from an early stage, and that Clarke was careful to avoid the more contentious works, such as "Ulysses", in September 1930 Cosgrave told Clarke that the window had been rejected, as certain representations 'would give rise to misunderstanding and much adverse comment.'

Clarke's classic depiction of Joxer from O'Casey's "Juno and the Paycock" together with that of the thinly-draped nude in Liam O'Flahery's "Mr Gilbooley" and the suggestively over-tight trousers of Synge's "Playboy", were the prime causes for the rejection: the Irish Secretary of Industry and Commerce, R.C. Ferguson, stated that 'A nation famed as a Catholic stronghold was to be represented as bizarre, almost viciously evil people steeped in sex and drunkenness and, yes, sin.' Clarke's widow later refunded her husband's fee and reclaimed the window from the State. It is now widely regarded as one of the finest examples of 20th-century stained glass.

Although Clarke sank into relative obscurity for a long time, some artists and writers have always maintained a faith in him and endeavoured to keep his name alive, possibly even to revive his reputation. Foremost among those has to be Nicola Gordon Bowe, tutor, lecturer and director of the MA Course in the History of Design and the Applied Arts, NCAD, Dublin (National University of Ireland) and author of "The Life And Work Of Harry Clarke" (Irish Academic Press Ltd).

Savoy Books in Manchester have always championed Clarke as being a true visionary and a real artist, as distinct from the millions of careerists churning out attention-seeking soap-bubbles to tickle the jaded palates of a public looking for distraction. David Britton's drawings,

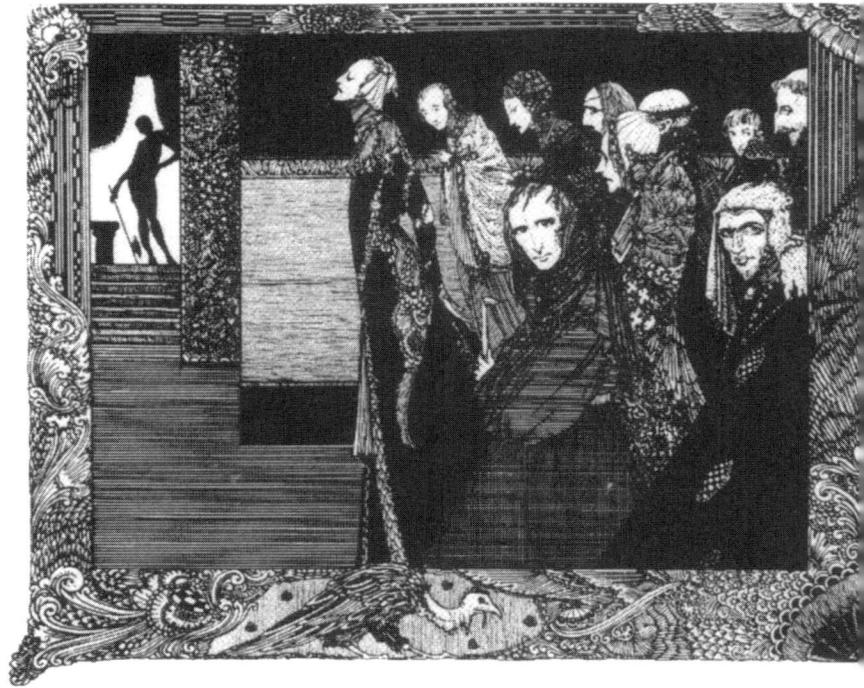

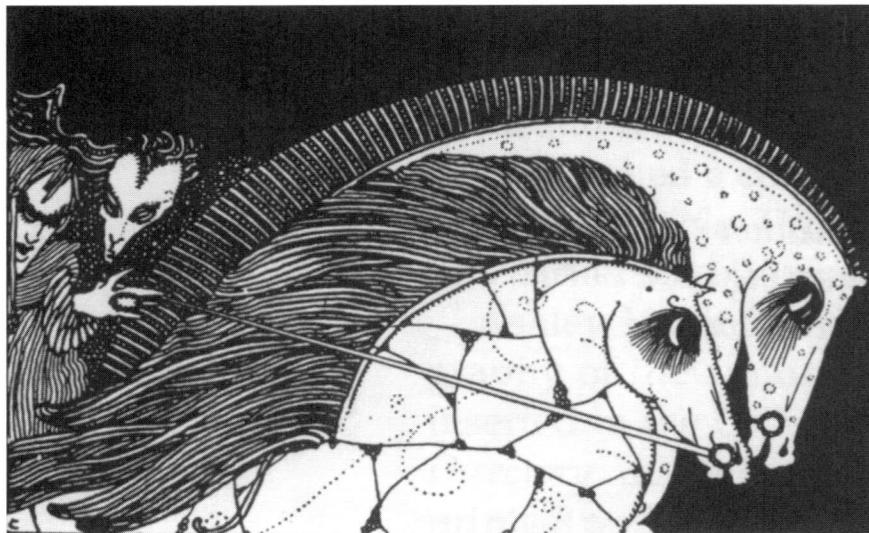

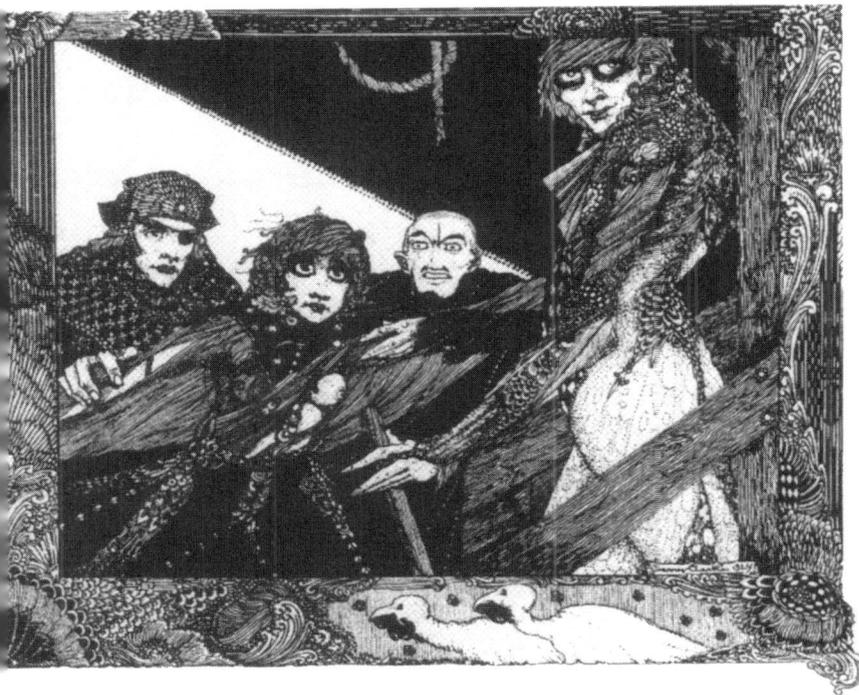

which appeared in his earliest publications (such as "Crucified Toad") drew on a lot of Clarke's stylistic mechanisms. Examples of these can be seen in Britton's drawings in "Savoy Dreams" (his accompanying pictures for Mike Butterworth's "A Hurricane In A Night Jar") in Moorcock's "New Nature Of The Catastrophe" and in Jack Trevor Story's book "The Screwtape Lettuce". Britton's prose style in his series of books about Lord Horror (based on wartime traitor and nazi-sympathiser William Joyce) could almost be seen, in their baroque strangeness, to be a verbal equivalent of Clarke's art.

Manchester artist John Coulthart frequently incorporates stylistic elements borrowed from artists he admires (from Piranesi and Doré to Virgil Finlay and Burne Hogarth). In his amazing art for the graphic novel "Reverbstorm" Coulthart has created a collage of images and scenes reflecting famous modernist paintings and pulp comics alike, offered up partly as tribute to the artists he admires, and synthesised into a unique and powerful vision of cosmic delirium. Clarke is among the artists to whom he pays tribute in this comic, as he draws strongly on Clarke's frenzied sinuous use of line and the powerful, almost bludgeoning use of chiaroscuro. In one panel in particular, called "The Weird of Spring Heeled Jack" (reproduced in the Creation Oneiros volume "The Haunter of the Dark") there is a recognisable pastiche of Clarke's illustrations for Poe.

'TALES OF MYSTERY AND IMAGINATION'

In his "Philosophy of Composition" Edgar Allan Poe claimed that his purpose as a writer was to make the realization of a work of art depend on a prior, methodical organisation of its elements in view of producing a desired effect. However much he may have believed that this was the sum and total of his work, even a cursory analysis of a dozen of his pieces will show that although he 'moulded' and 'shaped' the material consciously and meticulously, the source of his inspiration was always buried somewhere deep in the caverns of an apocalyptic subconscious, hung with vast storm clouds and pierced by lightning flashes.

In his biographical notes of Poe, Baudelaire declared "Literary jealousies, infinite vertigo, marital woe, the humiliation of poverty; Poe fled all of it in the darkness of his drunken stupor as if in the darkness of the grave. For he drank not as a lush, but as a barbarian." The power of Poe's writings stems from the *frisson* between his high intellectual faculties on the one hand and his atavistic self-destructiveness on the other.

Harry Clarke's illustrations for Poe's tales do not merely depict various scenes from the tales (often with a fair bit of artistic license as regards interpretation) but also perfectly capture the mood of despair and nihilism, coupled with the hysterical laughter of the infinite one often imagines when reading Poe's pieces. All Clarke's distinctive trademarks are there; the ornate and profuse use of detail and decoration, and the sinuous lines and stylised postures of the figures, still graceful but now also contorted into expressions of maniacal obsession, depravity and insanity, horror and mortal terror. Often, rather than graphically depicting the dynamic events described in a story, the illustration seems more

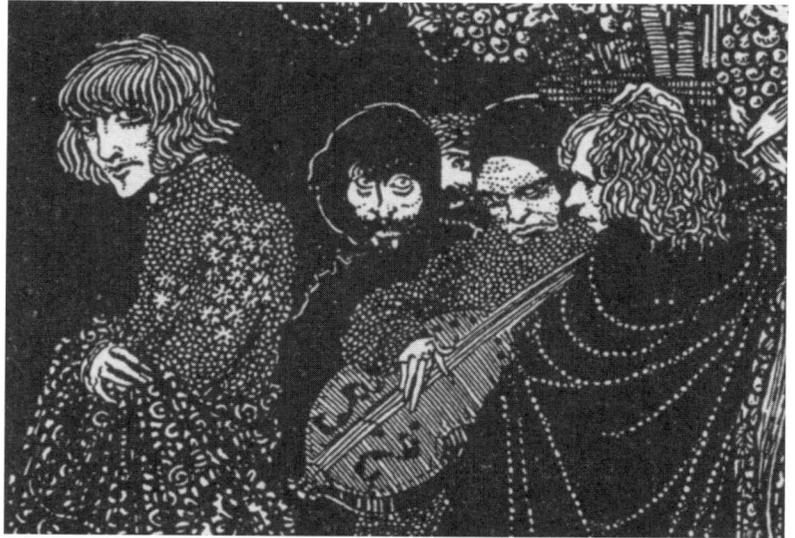

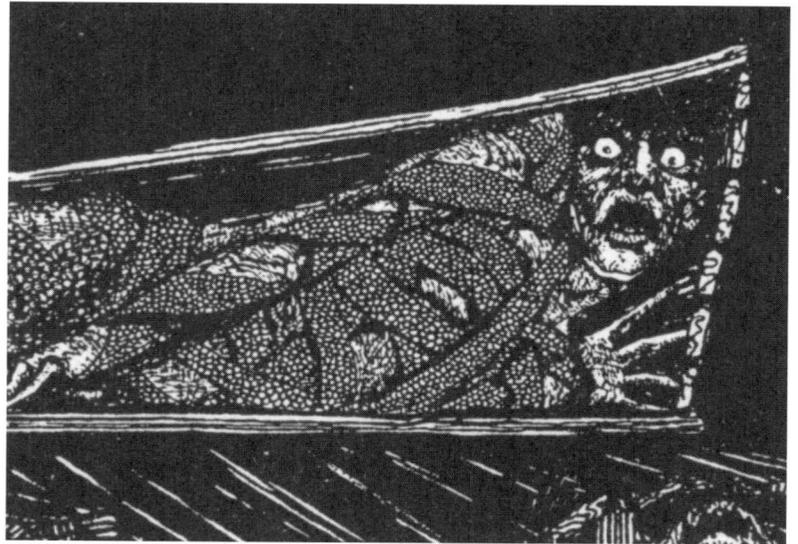

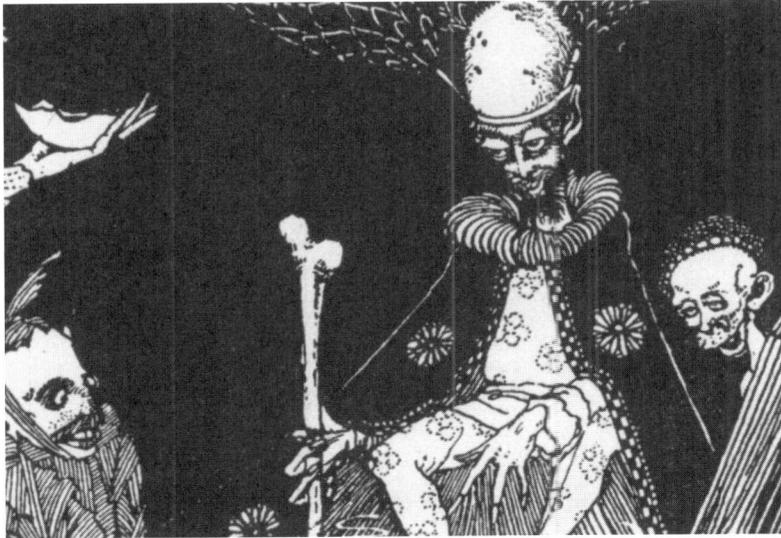

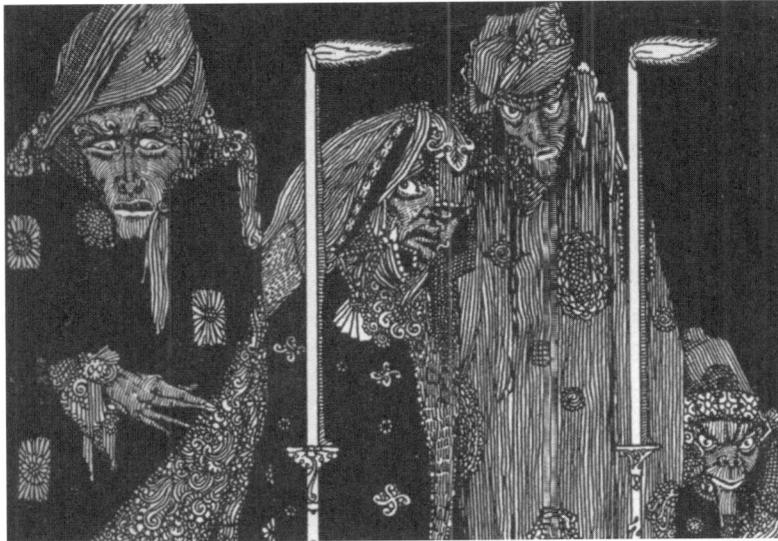

like some weird still-life or a frozen Byzantine icon. Frequently figures cluster together in enigmatic and symbolic groupings reminiscent of the witches and devils in Goya's "Los Caprichos".

But despite the macabre and often grisly subject matter, the effect one comes away with is of a transcendent beauty – a 'convulsive beauty' as Andre Breton called it – created by the tension between irreconcilably opposed elements placed in abnormal juxtaposition, or the chance meeting of normally distant and unlikely material; in this instance, the horrific or melancholy subject matter and the exquisitely graceful execution of the drawings.

A strong current of sickly eroticism runs through all of the drawings; the suppressed and controlled fervour of the lines threatens a perpetually impending explosion of violence, an undercurrent of extreme algolagnia, of sexually-based masochism driven to the point of death and beyond. In many of the illustrations, as with the stories themselves, this manifests as necrophilia, and this theme would emerge again in Clarke's illustrations for "Faust" and the poetry of Swinburne. In the case of the former, it would be far less macabre and bloody, tending instead towards surreal distortions and delirium. In the latter, this masochism finally came truly out in the open, parading shamelessly and fetishistically across the pages.

One wonders how Clarke's career and genius would have developed had they not been cut prematurely short. At the point where they were curtailed, his visions were clearly becoming more surrealistic and experimental. He would have been the ideal artist to illustrate Lautréamont's "Maldoror" or the works of HP Lovecraft (who was an admirer). Recently there has been some

revival of interest in Clarke's work – notably in the award-winning DVD "Darkness In Light" directed by John J Doherty. All we can do is admire what he has left us, and hope that sooner rather than later he will be generally elevated to a more prominent place in art history.

TABLE OF ILLUSTRATIONS

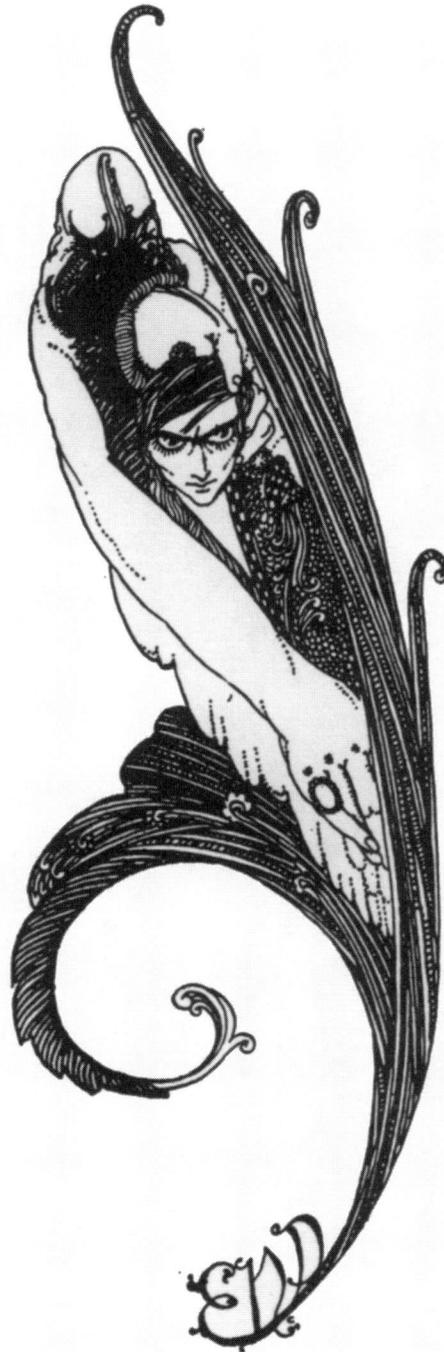

Illustrations for Edgar Allan Poe's
TALES OF MYSTERY AND IMAGINATION

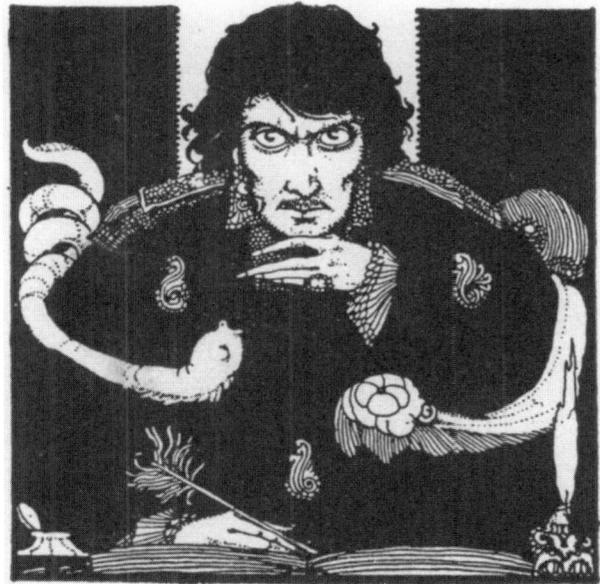

THE FACTS IN THE CASE OF M. VALDEMAR
"Upon the bed there lay a nearly liquid mass of loathesome – of detestable putridity" (first version, 1914)

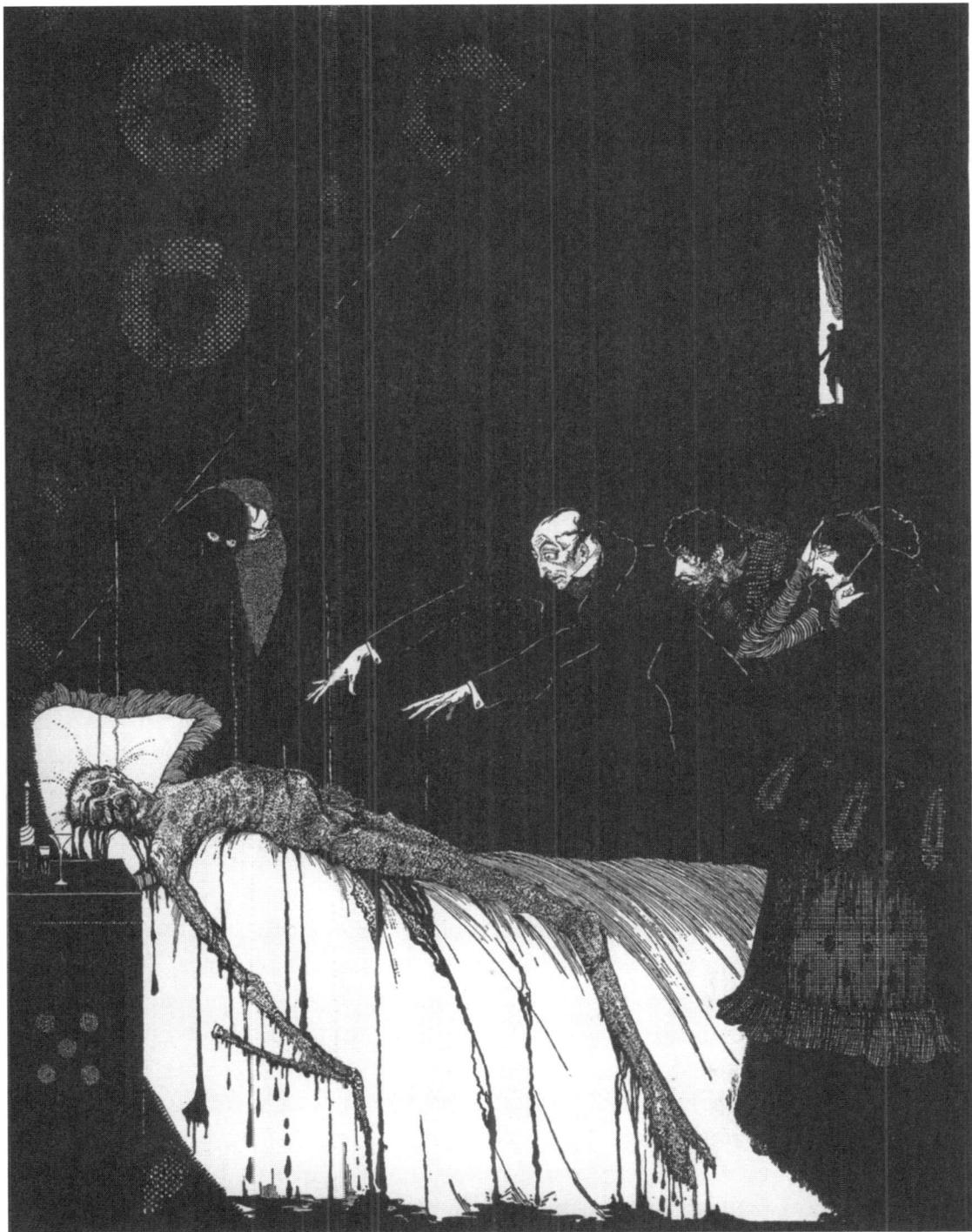

... There was an instant return of the hectic circles on the cheeks; the tongue quivered, or rather rolled violently in the mouth (although the jaws and lips remained rigid as before;) and at length the same hideous voice which I have already described, broke forth: "For God's sake! – quick! – quick! – put me to sleep – or, quick! – waken me! – quick! – I say to you that I am dead!"

I was thoroughly unnerved, and for an instant remained undecided what to do. At first I made an endeavor to re-compose the patient; but, failing in this through total abeyance of the will, I retraced my steps and as earnestly struggled to awaken him. In this attempt I soon saw that I should be successful – or at least I soon fancied that my success would be complete - and I am sure that all in the room were prepared to see the patient awaken.

For what really occurred, however, it is quite impossible that any human being could have been prepared.

As I rapidly made the mesmeric passes, amid ejaculations of "dead! dead!" absolutely bursting from the tongue and not from the lips of the sufferer, his whole frame at once – within the space of a single minute, or even less, shrunk – crumbled – absolutely rotted away beneath my hands. Upon the bed, before that whole company, there lay a nearly liquid mass of loathsome – of detestable putridity.

THE FACTS IN THE CASE OF M. VALDEMAR
"Upon the bed there lay a nearly liquid mass of loathsome – of detestable putridity" (second version, 1918)

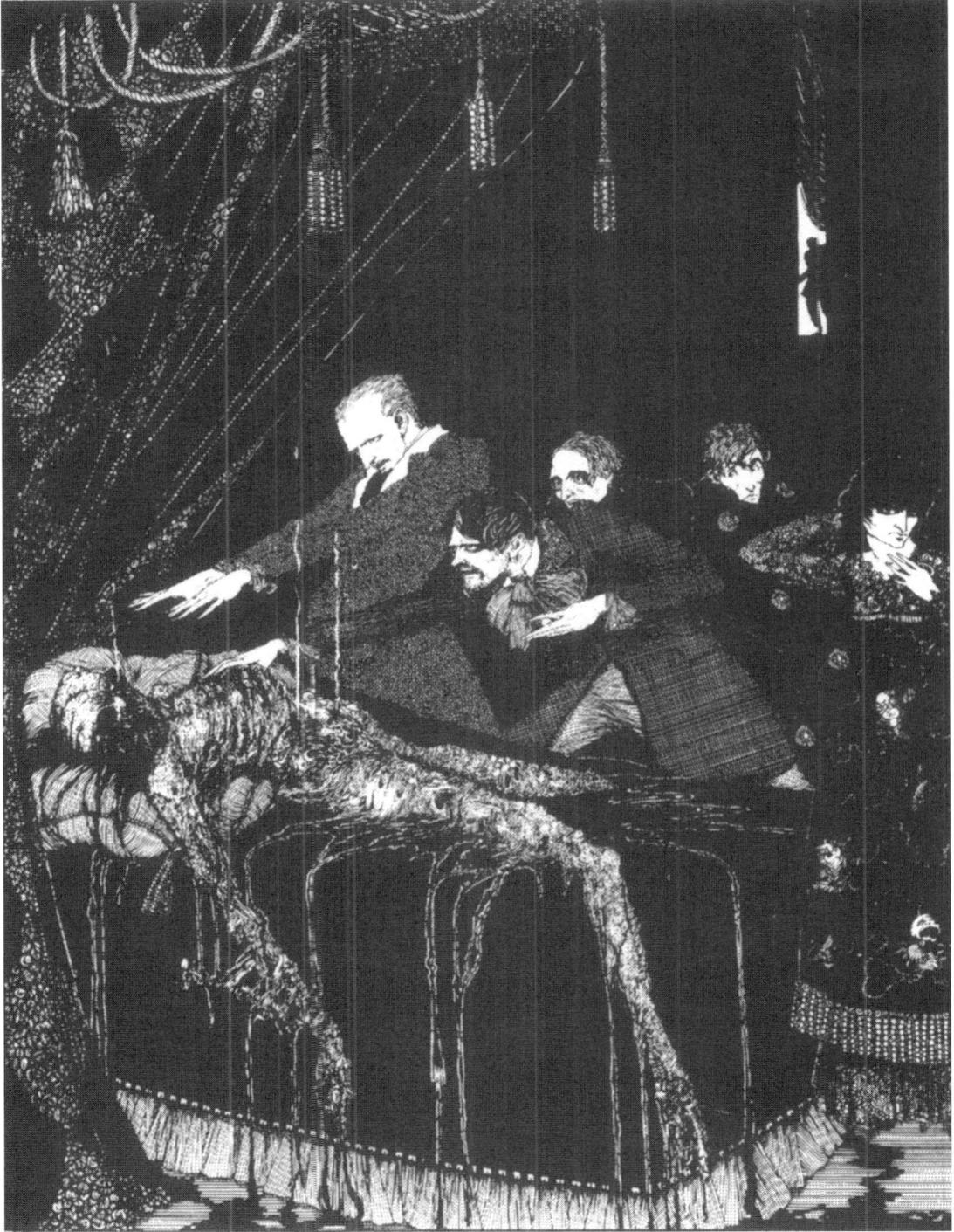

... A child, slipping from the arms of its own mother, had fallen from an upper window of the lofty structure into the deep and dim canal. The quiet waters had closed placidly over their victim; and, although my own gondola was the only one in sight, many a stout swimmer, already in the stream, was seeking in vain upon the surface, the treasure which was to be found, alas! only within the abyss. Upon the broad black marble flagstones at the entrance of the palace, and a few steps above the water, stood a figure which none who then saw can have ever since forgotten. It was the Marchesa Aphrodite – the adoration of all Venice – the gayest of the gay – the most lovely where all were beautiful – but still the young wife of the old and intriguing Mentoni, and the mother of that fair child, her first and only one, who now, deep beneath the murky water, was thinking in bitterness of heart upon her sweet caresses, and exhausting its little life in struggles to call upon her name. ...

THE ASSIGNATION
"It was the Marchesa Aphrodite – the adoration of all Venice"

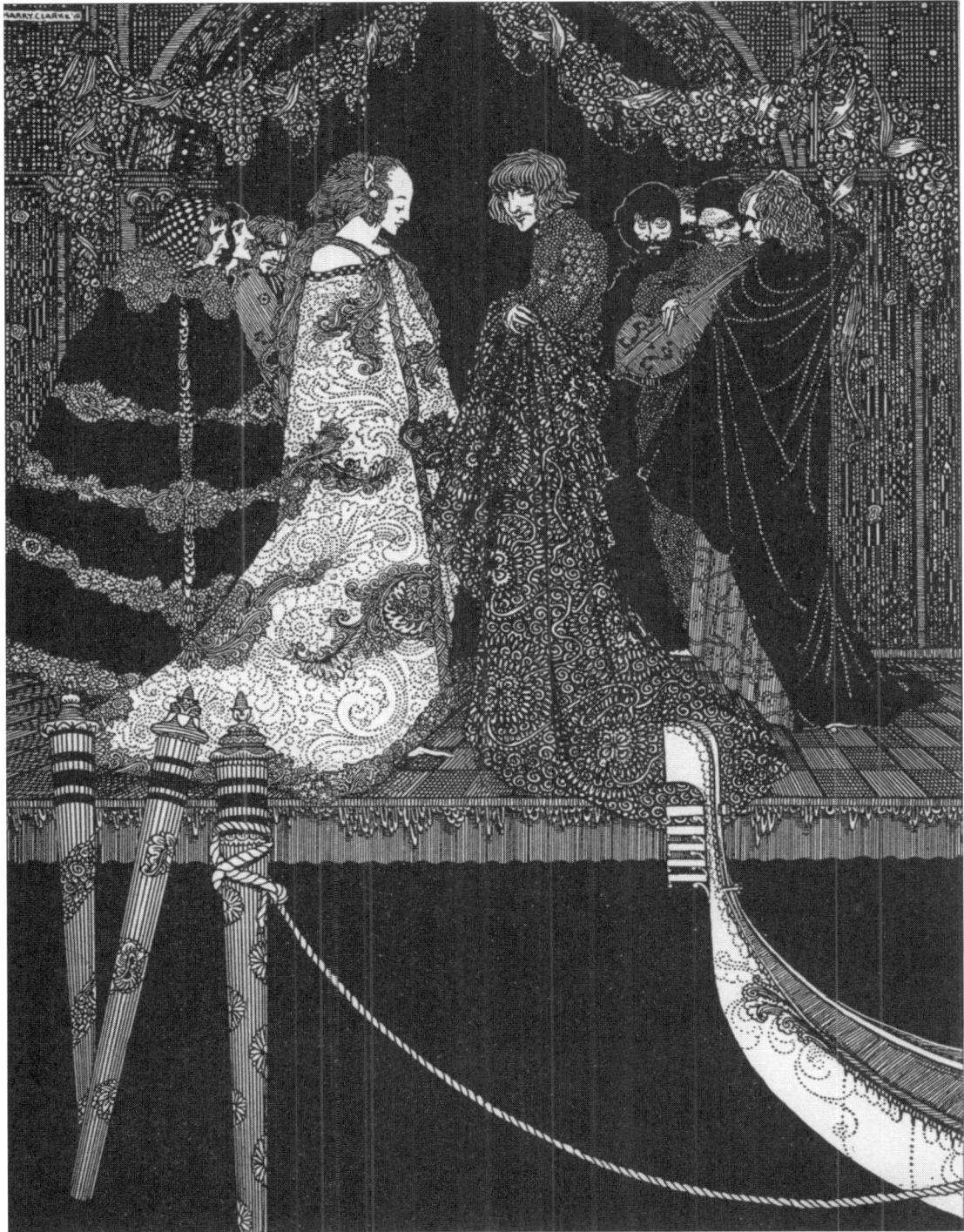

... She stood alone. Her small, bare, and silvery feet gleamed in the black mirror of marble beneath her. Her hair, not as yet more than half loosened for the night from its ball-room array, clustered, amid a shower of diamonds, round and round her classical head, in curls like those of the young hyacinth. A snowy-white and gauze-like drapery seemed to be nearly the sole covering to her delicate form; but the mid-summer and midnight air was hot, sullen, and still, and no motion in the statue-like form itself, stirred even the folds of that raiment of very vapor which hung around it as the heavy marble hangs around the Niobe. Yet – strange to say! – her large lustrous eyes were not turned downwards upon that grave wherein her brightest hope lay buried--but riveted in a widely different direction! The prison of the Old Republic is, I think, the stateliest building in all Venice – but how could that lady gaze so fixedly upon it, when beneath her lay stifling her only child? Yon dark, gloomy niche, too, yawns right opposite her chamber window – what, then, *could* there be in its shadows – in its architecture – in its ivy-wreathed and solemn cornices – that the Marchesa di Mentoni had not wondered at a thousand times before? Nonsense! – Who does not remember that, at such a time as this, the eye, like a shattered mirror, multiplies the images of its sorrow, and sees in innumerable far-off places, the wo which is close at hand?

Many steps above the Marchesa, and within the arch of the water-gate, stood, in full dress, the Satyr-like figure of Mentoni himself. He was occasionally occupied in thrumming a guitar, and seemed *ennuyé* to the very death, as at intervals he gave directions for the recovery of his child. Stupified and aghast, I had myself no power to move from the upright position I had assumed upon first hearing the shriek, and must have presented to the eyes of the agitated group a spectral and ominous appearance, as with pale countenance and rigid limbs, I floated down among them in that funereal gondola. ...

THE ASSIGNATION
"I myself had no power to move from the upright position I had assumed"

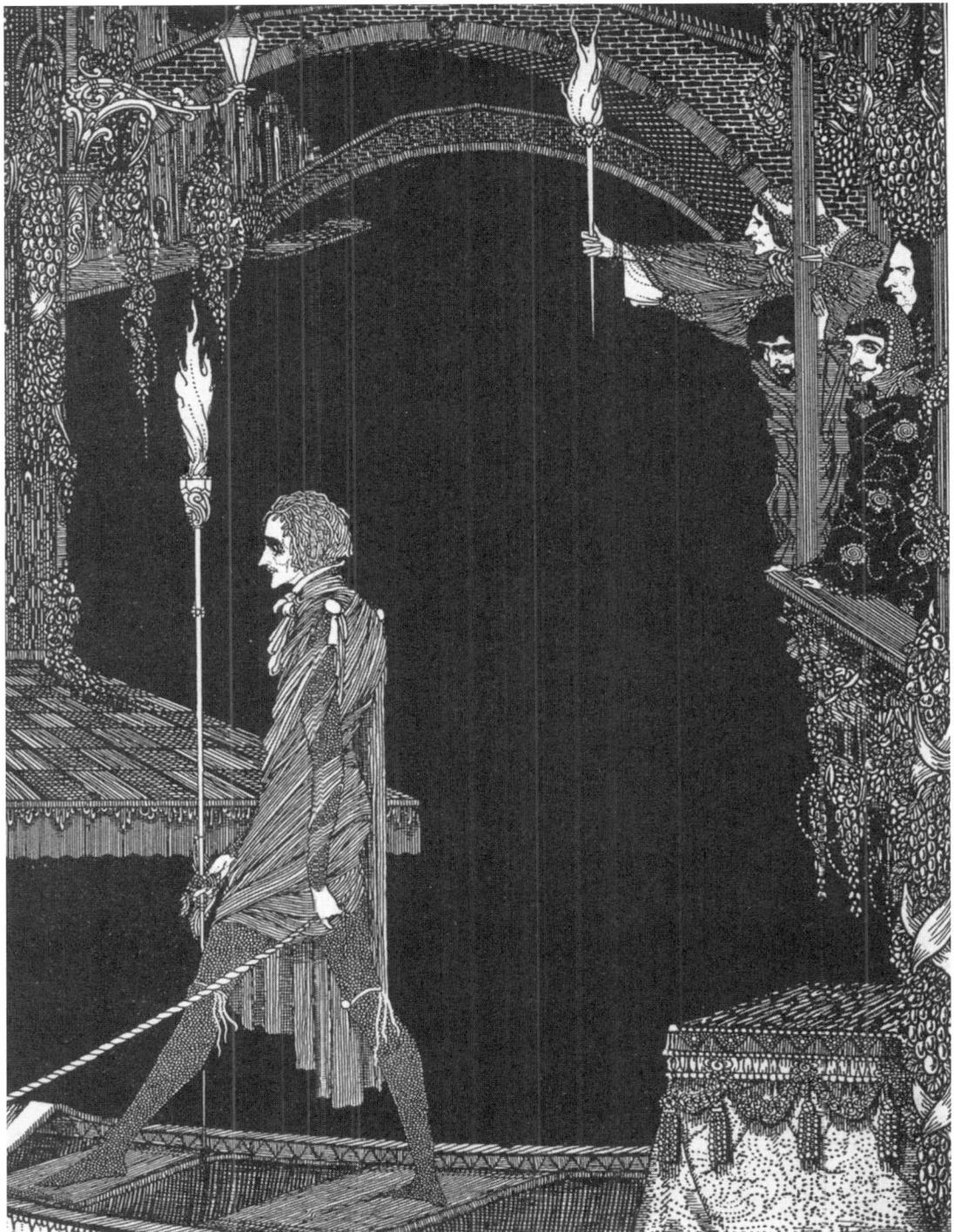

... I found myself sitting in the library, and again sitting there alone. It seemed that I had newly awakened from a confused and exciting dream. I knew that it was now midnight, and I was well aware, that since the setting of the sun, Berenice had been interred. But of that dreary period which intervened I had no positive, at least no definite comprehension. Yet its memory was replete with horror – horror more horrible from being vague, and terror more terrible from ambiguity. It was a fearful page in the record my existence, written all over with dim, and hideous, and unintelligible recollections. I strived to decypher them, but in vain; while ever and anon, like the spirit of a departed sound, the shrill and piercing shriek of a female voice seemed to be ringing in my ears. I had done a deed – what was it? I asked myself the question aloud, and the whispering echoes of the chamber answered me, – "*what was it?*"?

BERENICE
"It was a fearful page in the record of my existence"

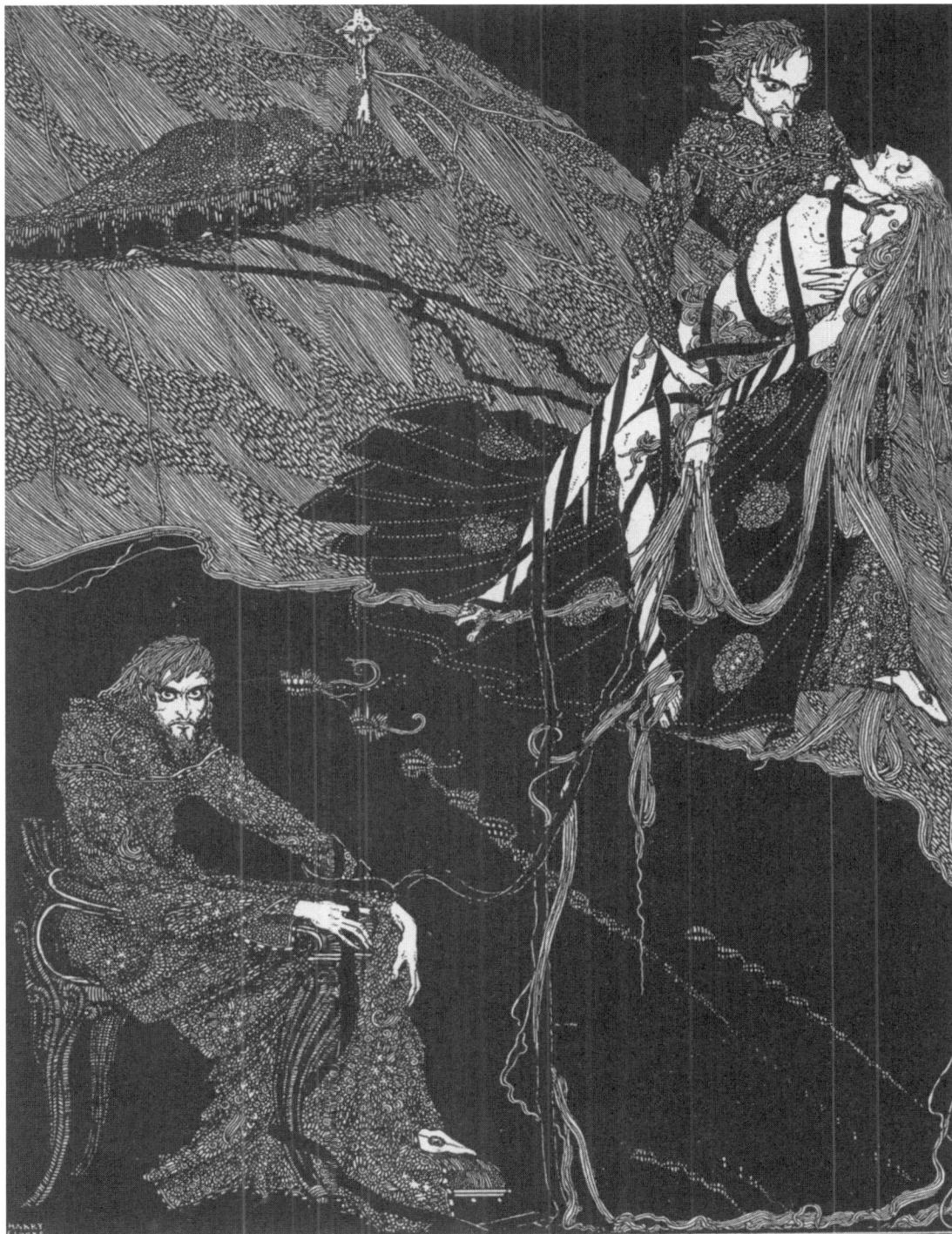

... But may God shield and deliver me from the fangs of the Arch-Fiend! No sooner had the reverberation of my blows sunk into silence, than I was answered by a voice from within the tomb! – by a cry, at first muffled and broken, like the sobbing of a child, and then quickly swelling into one long, loud, and continuous scream, utterly anomalous and inhuman – a howl – a wailing shriek, half of horror and half of triumph, such as might have arisen only out of hell, conjointly from the throats of the dammed in their agony and of the demons that exult in the damnation.

Of my own thoughts it is folly to speak. Swooning, I staggered to the opposite wall. For one instant the party upon the stairs remained motionless, through extremity of terror and of awe. In the next, a dozen stout arms were toiling at the wall. It fell bodily. The corpse, already greatly decayed and clotted with gore, stood erect before the eyes of the spectators. Upon its head, with red extended mouth and solitary eye of fire, sat the hideous beast whose craft had seduced me into murder, and whose informing voice had consigned me to the hangman. I had walled the monster up within the tomb!

THE BLACK CAT
"I had walled the monster up within the tomb!"

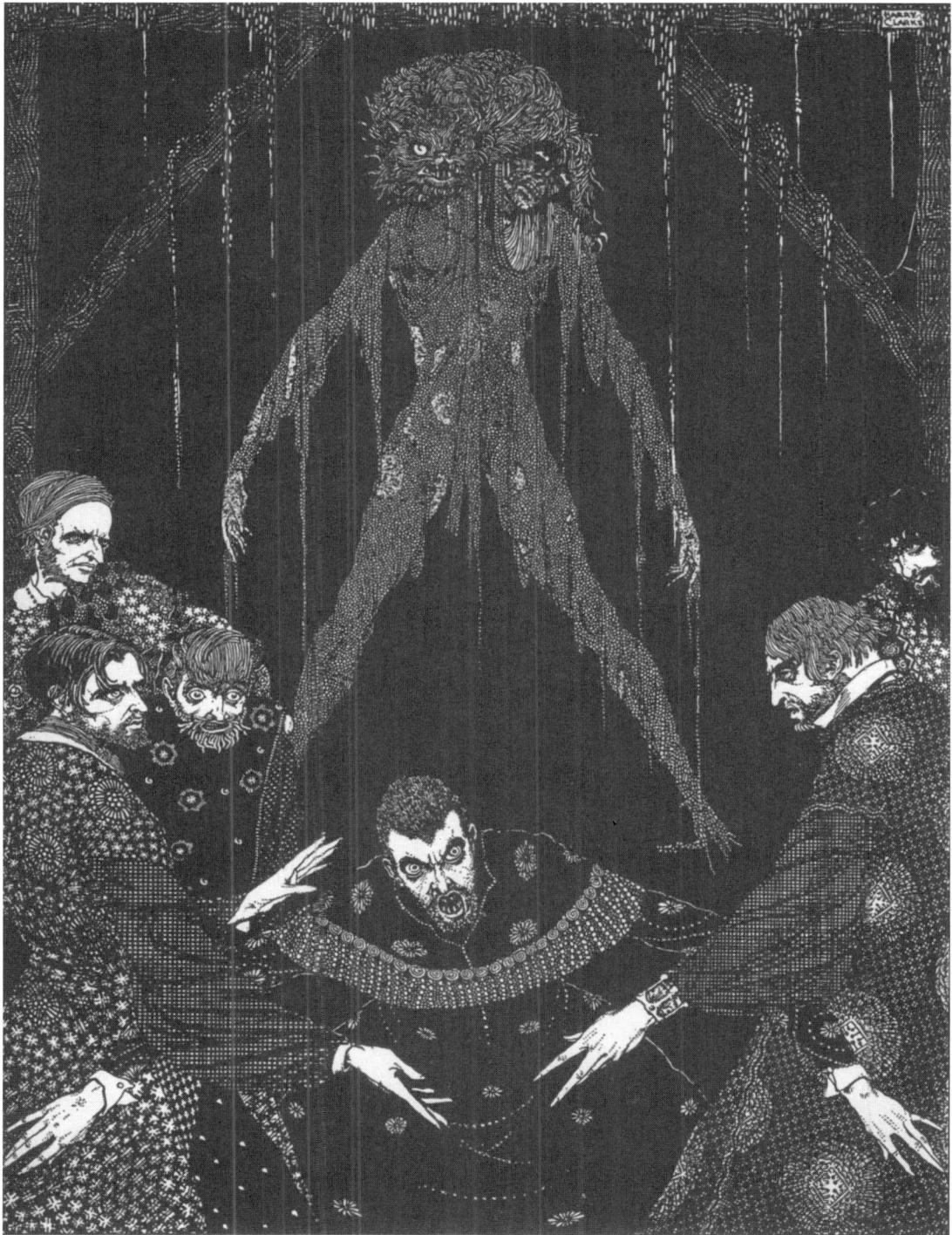

... It was now midnight, and my task was drawing to a close. I had completed the eighth, the ninth, and the tenth tier. I had finished a portion of the last and the eleventh; there remained but a single stone to be fitted and plastered in. I struggled with its weight; I placed it partially in its destined position. But now there came from out the niche a low laugh that erected the hairs upon my head. It was succeeded by a sad voice, which I had difficulty in recognising as that of the noble Fortunato. The voice said–

"Ha! ha! ha! – he! he! – a very good joke indeed – an excellent jest. We will have many a rich laugh about it at the palazzo – he! he! he! – over our wine – he! he! he!"

"The Amontillado!" I said.

"He! he! he! – he! he! he! – yes, the Amontillado. But is it not getting late? Will not they be awaiting us at the palazzo, the Lady Fortunato and the rest? Let us be gone."

"Yes," I said, "let us be gone."

"*For the love of God, Montressor!*"

"Yes," I said, "for the love of God!"

But to these words I hearkened in vain for a reply. I grew impatient. I called aloud–

"Fortunato!"

No answer. I called again–

"Fortunato!"

No answer still. I thrust a torch through the remaining aperture and let it fall within. There came forth in return only a jingling of the bells. My heart grew sick – on account of the dampness of the catacombs. I hastened to make an end of my labor. I forced the last stone into its position; I plastered it up. Against the new masonry I re-erected the old rampart of bones. For the half of a century no mortal has disturbed them. *In pace requiescat*!

THE CASK OF AMONTILLADO
" '*For the love of God! Montresor!*'
'Yes,' I said, 'for the love of God!'"

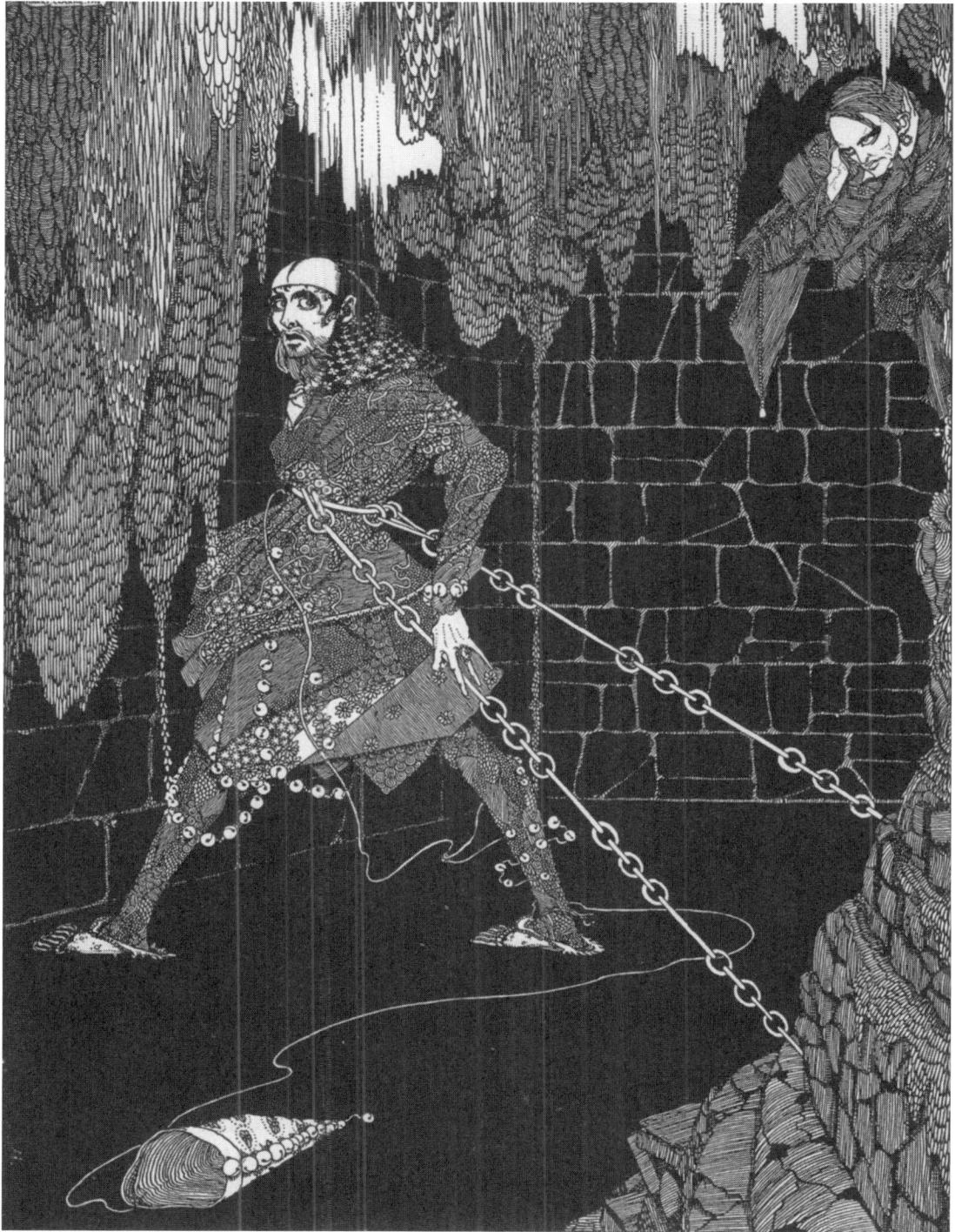

... "Never shall I forget the sensations of awe, horror, and admiration with which I gazed about me. The boat appeared to be hanging, as if by magic, midway down, upon the interior surface of a funnel vast in circumference, prodigious in depth, and whose perfectly smooth sides might have been mistaken for ebony, but for the bewildering rapidity with which they spun around, and for the gleaming and ghastly radiance they shot forth, as the rays of the full moon, from that circular rift amid the clouds which I have already described, streamed in a flood of golden glory along the black walls, and far away down into the inmost recesses of the abyss." ...

A DESCENT INTO THE MAELSTROM
"The boat appeared to be hanging, as if by magic, ...upon the interior surface of a funnel"

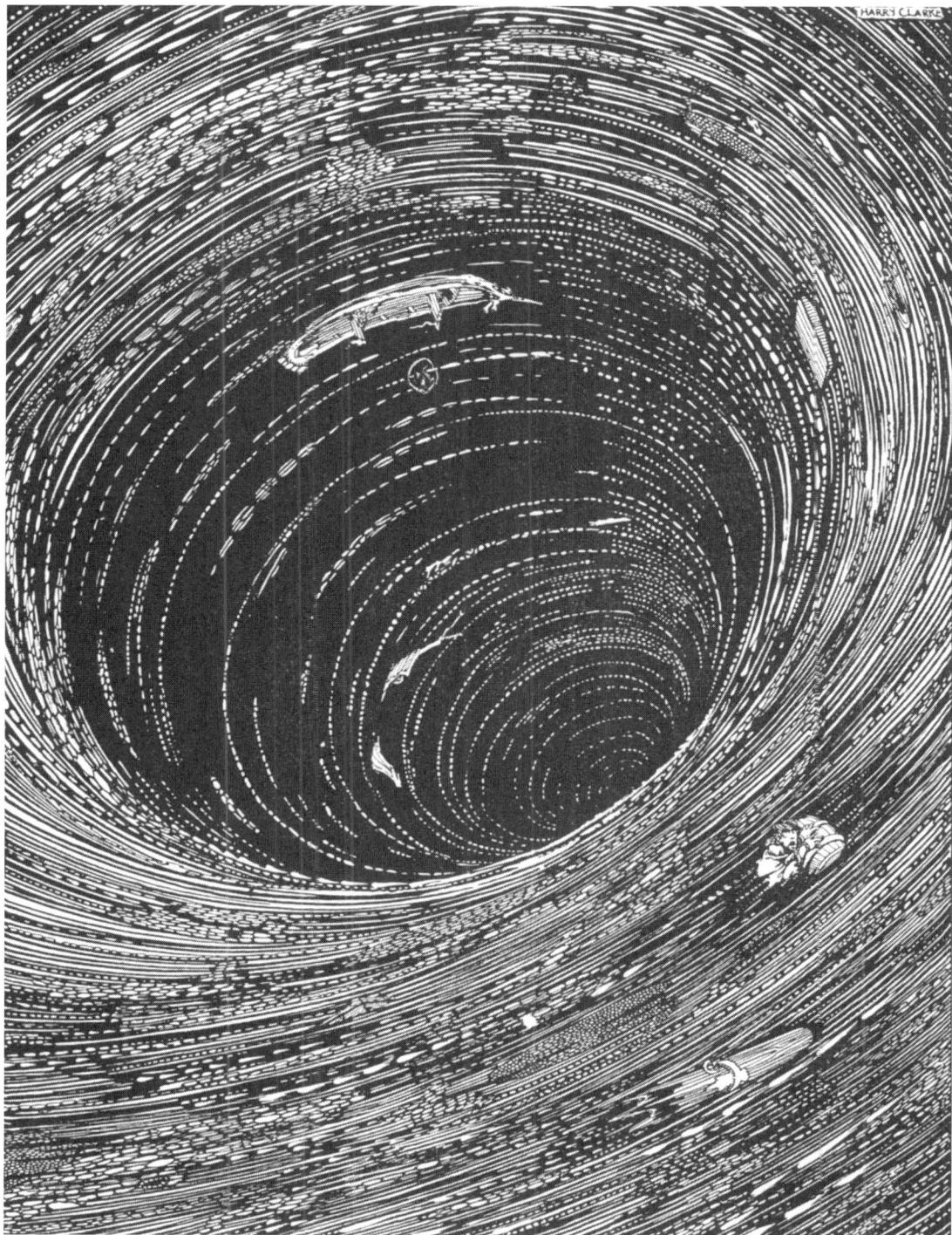

... As if in the superhuman energy of his utterance there had been found the potency of a spell – the huge antique pannels to which the speaker pointed, threw slowly back, upon the instant, their ponderous and ebony jaws. It was the work of the rushing gust – but then without those doors there *did* stand the lofty and enshrouded figure of the lady Madeline of Usher. There was blood upon her white robes, and the evidence of some bitter struggle upon every portion of her emaciated frame. For a moment she remained trembling and reeling to and fro upon the threshold – then, with a low moaning cry. fell heavily inward upon the person of her brother, and in her violent and now final death-agonies, bore him to the floor a corpse, and a victim to the terrors he had anticipated.

From that chamber, and from that mansion, I fled aghast. The storm was still abroad in all its wrath as I found myself crossing the old causeway. Suddenly there shot along the path a wild light, and I turned to see whence a gleam so unusual could have issued; for the vast house and its shadows were alone behind me. The radiance was that of the full, setting, and blood-red moon, which now shone vividly through that once barely-discernible fissure, of which I have before spoken as extending from the roof of the building, in a zigzag direction, to the base. While I gazed, this fissure rapidly widened – there came a fierce breath of the whirlwind – the entire orb of the satellite burst at once upon my sight – my brain reeled as I saw the mighty walls rushing asunder – there was a long tumultuous shouting sound like the voice of a thousand waters – and the deep and dank tarn at my feet closed sullenly and silently over the fragments of the *"House of Usher"*.

THE FALL OF THE HOUSE OF USHER
"But then without those doors there *did* stand the lofty and enshrouded figure of the lady Madeline of Usher"

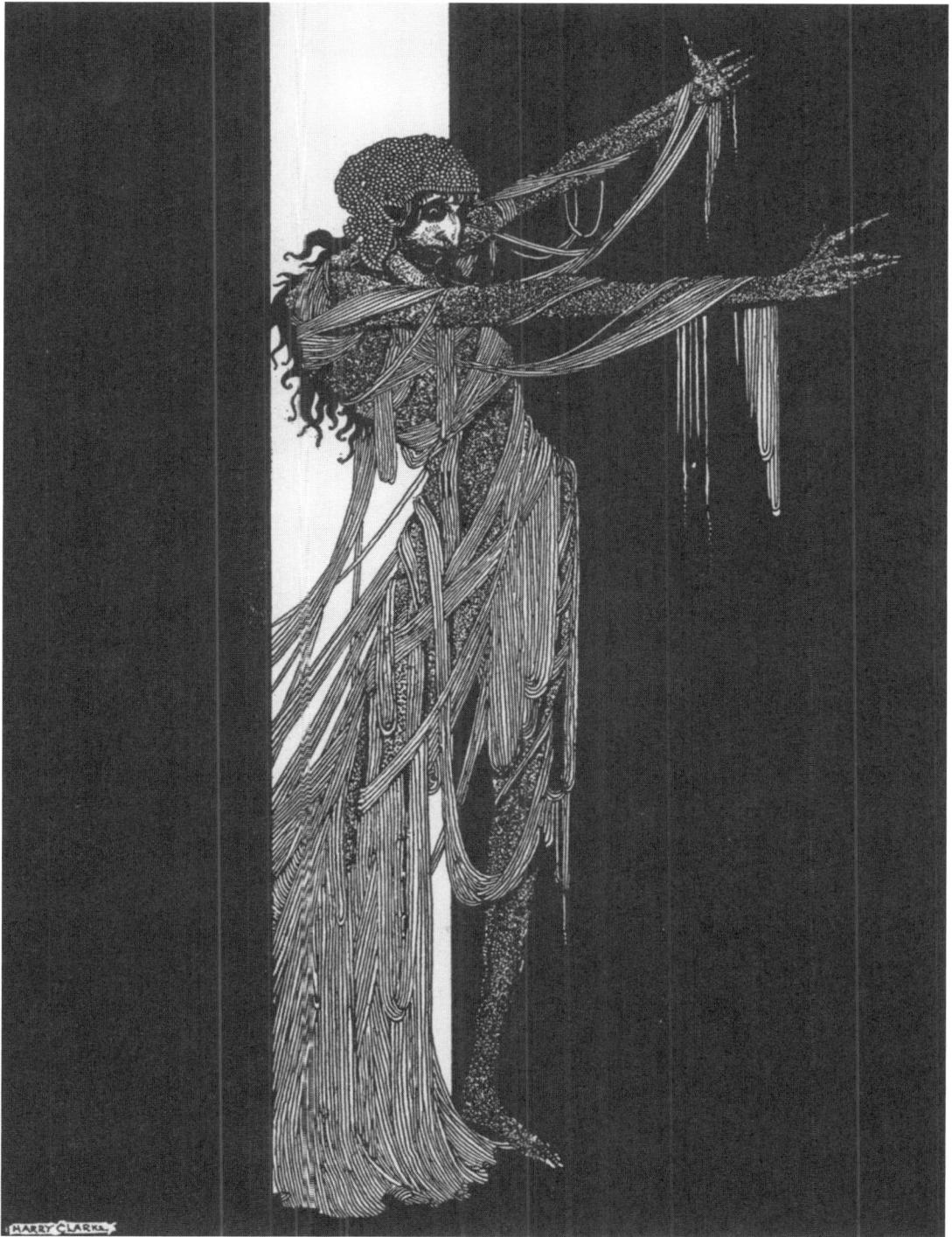

HARRY CLARKE

... We now worked in earnest, and never did I pass ten minutes of more intense excitement. During this interval we had fairly unearthed an oblong chest of wood, which, from its perfect preservation and wonderful hardness, had plainly been subjected to some mineralizing process – perhaps that of the Bi-chloride of Mercury. This box was three feet and a half long, three feet broad, and two and a half feet deep. It was firmly secured by bands of wrought iron, riveted, and forming a kind of open trelliswork over the whole. On each side of the chest, near the top, were three rings of iron – six in all – by means of which a firm hold could be obtained by six persons. Our utmost united endeavors served only to disturb the coffer very slightly in its bed. We at once saw the impossibility of removing so great a weight. Luckily, the sole fastenings of the lid consisted of two sliding bolts. These we drew back – trembling and panting with anxiety. In an instant, a treasure of incalculable value lay gleaming before us. As the rays of the lanterns fell within the pit, there flashed upwards a glow and a glare, from a confused heap of gold and of jewels, that absolutely dazzled our eyes. ...

THE GOLD BUG
"There flashed upward a glow and a glare"

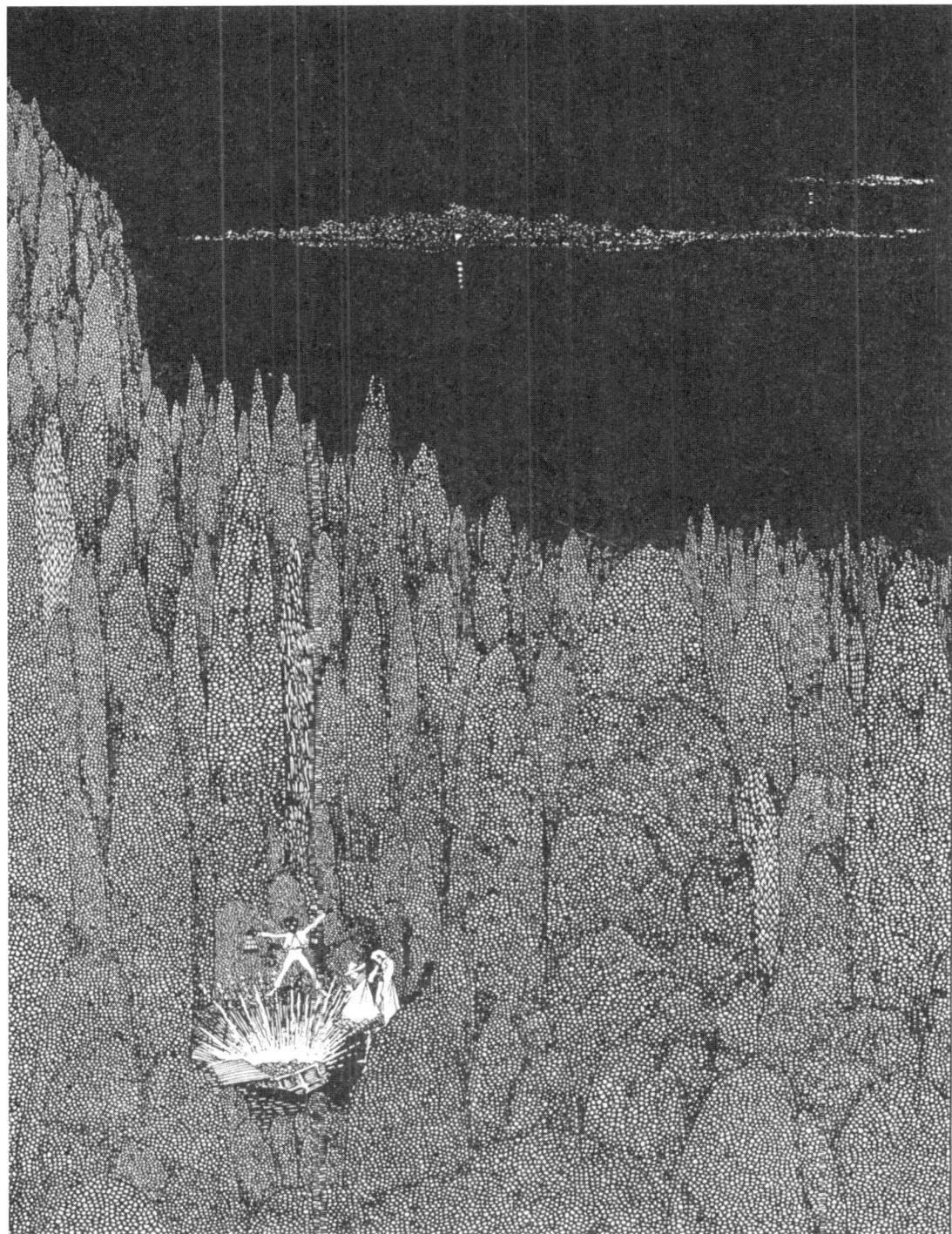

... "Avast there!" interrupted Legs, looking very serious, "avast there a bit, I say, and tell us who the devil ye all are, and what business ye have here, rigged off like the foul fiends, and swilling the snug blue ruin stowed away for the winter by my honest shipmate, Will Wimble the undertaker!"

At this unpardonable piece of ill-breeding, all the original company half started to their feet, and uttered the same rapid succession of wild fiendish shrieks which had before caught the attention of the seamen. The president, however, was the first to recover his composure, and at length, turning to Legs with great dignity, recommended:

"Most willingly will we gratify any reasonable curiosity on the part of guests so illustrious, unbidden though they be. Know then that in these dominions I am monarch, and here rule with undivided empire under the title of 'King Pest the First'." ...

KING PEST
"Avast there a bit, I say, and tell us who the Devil ye all are!"

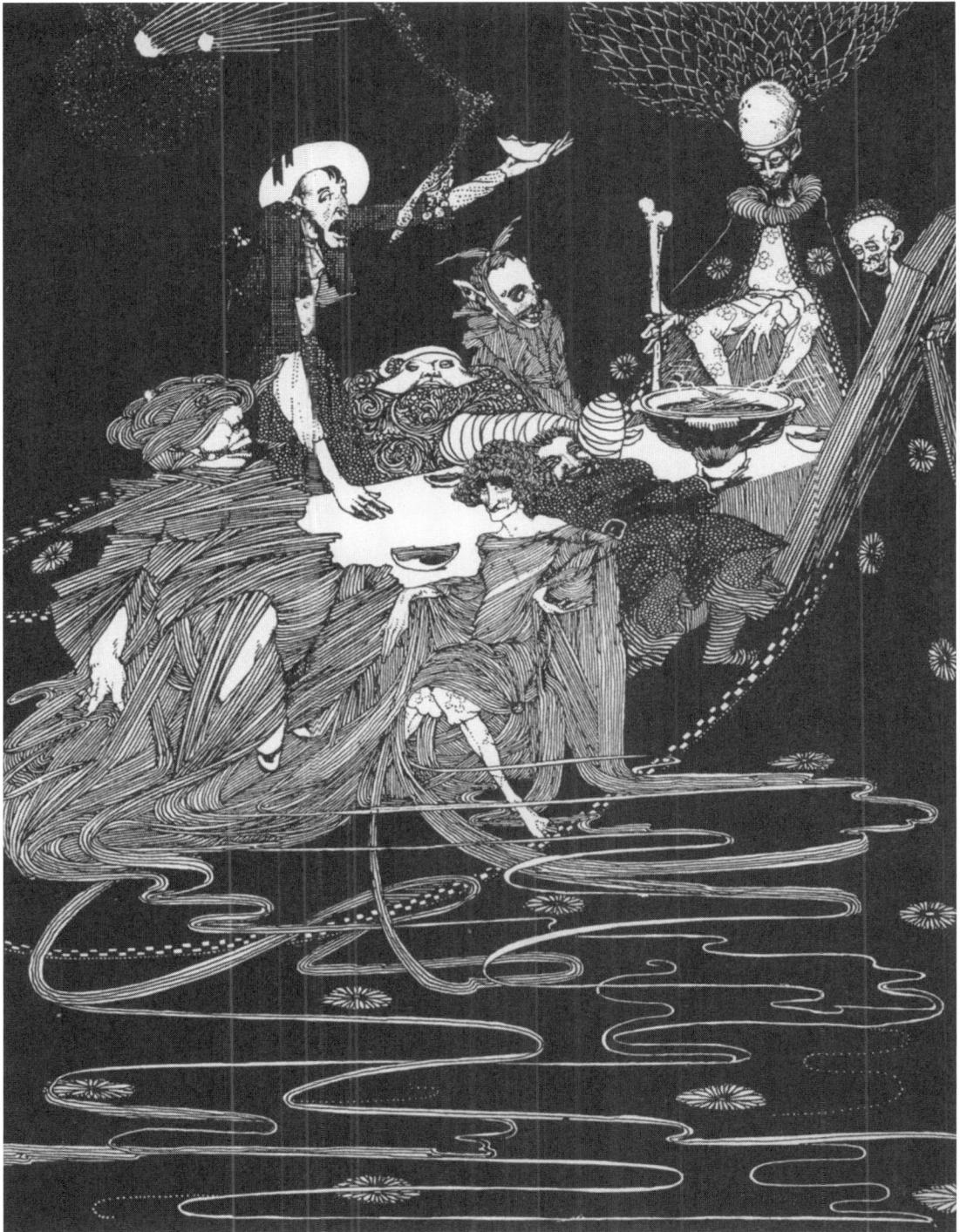

... The little vale into which I thus peered down from under the fog canopy could not have been more than four hundred yards long; while in breadth it varied from fifty to one hundred and fifty or perhaps two hundred. It was most narrow at its northern extremity, opening out as it tended southwardly, but with no very precise regularity. The widest portion was within eighty yards of the southern extreme. The slopes which encompassed the vale could not fairly be called hills, unless at their northern face. Here a precipitous ledge of granite arose to a height of some ninety feet; and, as I have mentioned, the valley at this point was not more than fifty feet wide; but as the visiter proceeded southwardly from the cliff, he found on his right hand and on his left, declivities at once less high, less precipitous, and less rocky. All, in a word, sloped and softened to the south; and yet the whole vale was engirdled by eminences, more or less high, except at two points. One of these I have already spoken of. It lay considerably to the north of west, and was where the setting sun made its way, as I have before described, into the amphitheatre, through a cleanly cut natural cleft in the granite embankment; this fissure might have been ten yards wide at its widest point, so far as the eye could trace it. ...

LANDOR'S COTTAGE
"The whole vale was engirdled by eminiences"

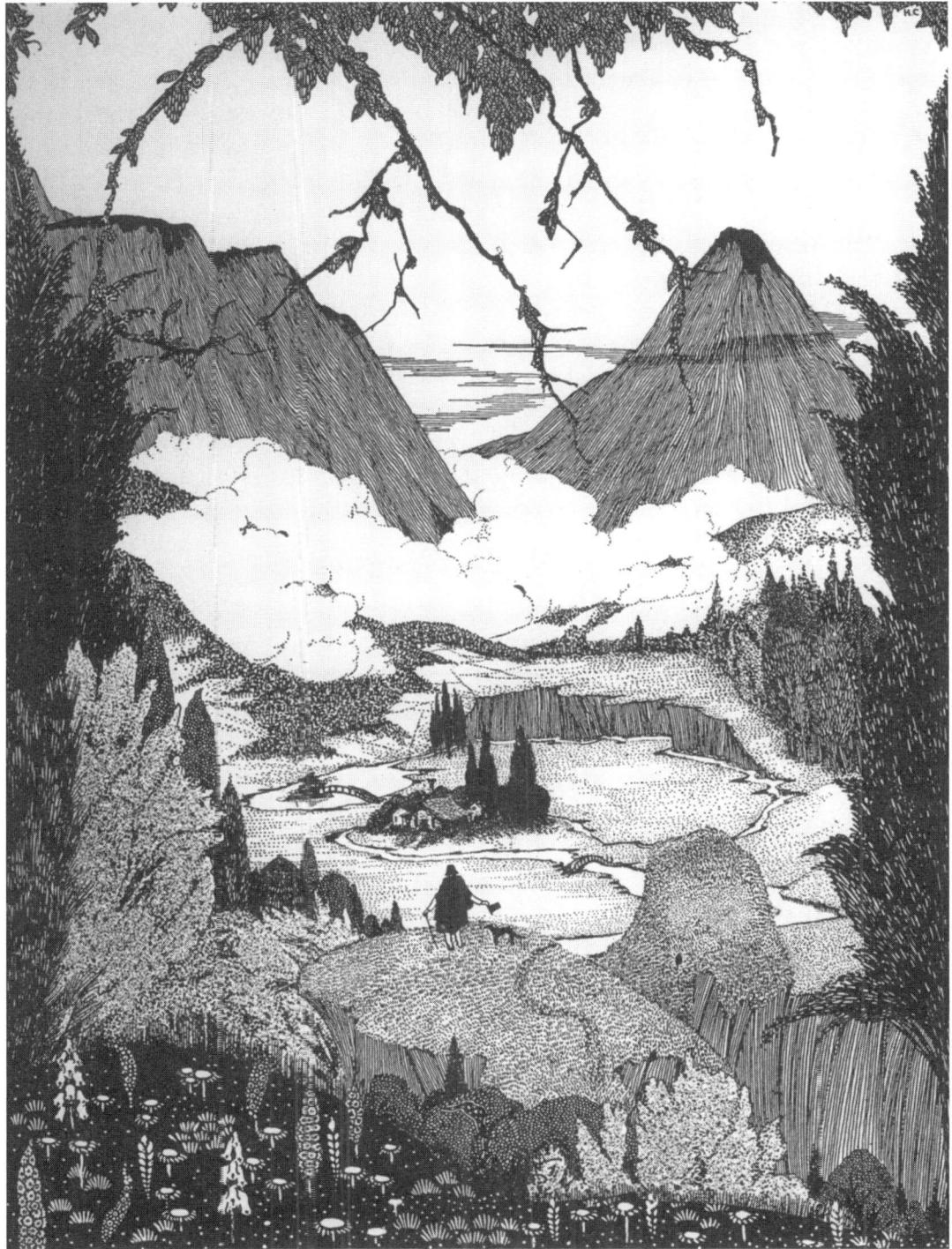

... In halls such as these – in a bridal chamber such as this – I passed, with the Lady of Tremaine, the unhallowed hours of the first month of our marriage – passed them with but little disquietude. That my wife dreaded the fierce moodiness of my temper – that she shunned me and loved me but little – I could not help perceiving; but it gave me rather pleasure than otherwise. I loathed her with a hatred belonging more to demon than to man. My memory flew back, (oh, with what intensity of regret!) to Ligeia, the beloved, the august, the beautiful, the entombed. I revelled in recollections of her purity, of her wisdom, of her lofty, her ethereal nature, of her passionate, her idolatrous love. Now, then, did my spirit fully and freely burn with more than all the fires of her own. In the excitement of my opium dreams (for I was habitually fettered in the shackles of the drug) I would call aloud upon her name, during the silence of the night, or among the sheltered recesses of the glens by day, as if, through the wild eagerness, the solemn passion, the consuming ardor of my longing for the departed, I could restore her to the pathway she had abandoned – ah, could it be forever? – upon the earth. ...

LIGEIA
"I would call aloud upon her name"

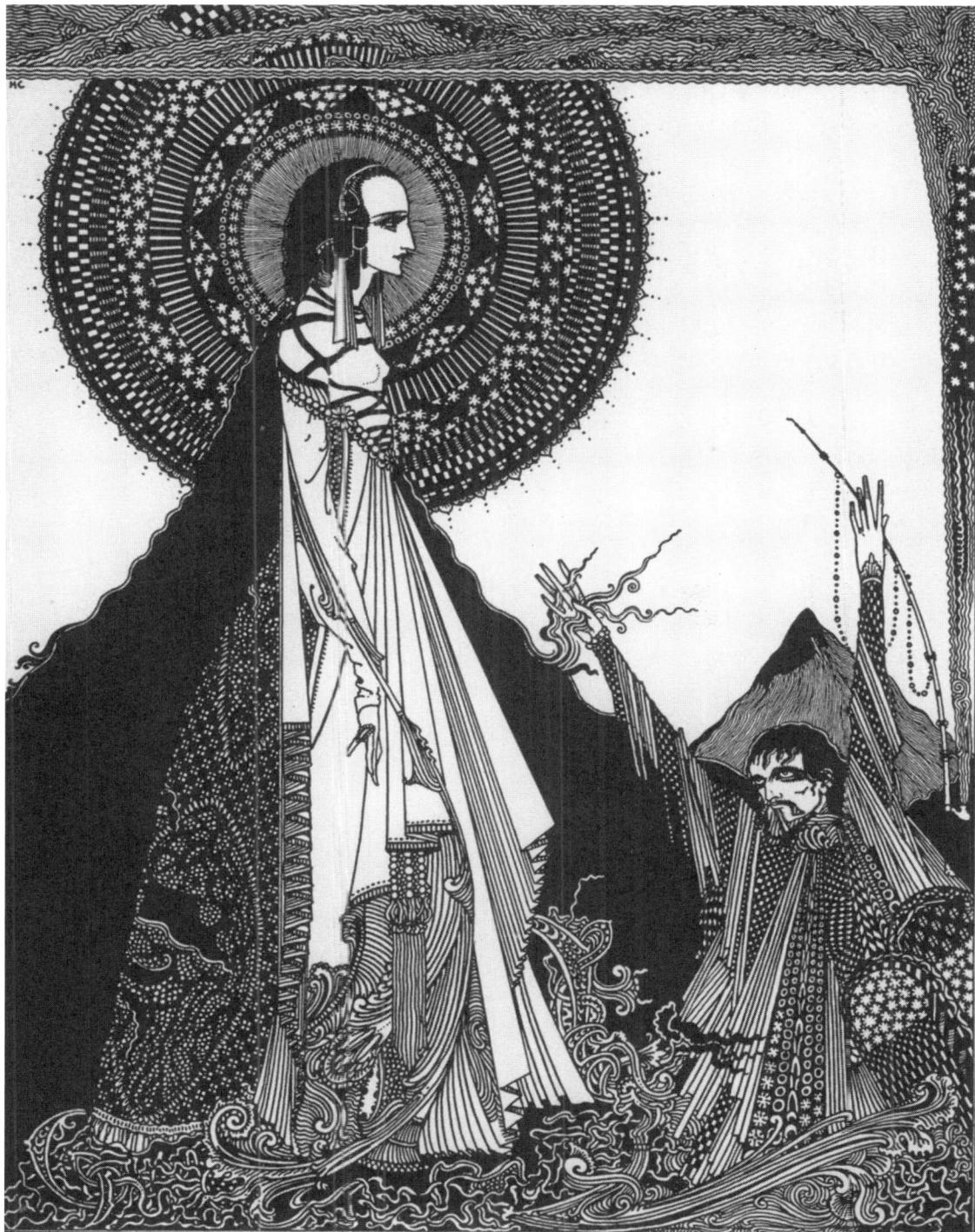

... The Duchess of Bless-my-Soul was sitting for her portrait; the Marquis of So-and-So was holding the Duchess' poodle; the Earl of This-and-That was flirting with her salts; and his Royal Highness of Touch-me-Not was leaning upon the back of her chair.

I approached the artist and turned up my nose.

"Oh, beautiful!" sighed her Grace.

"Oh my!" lisped the Marquis.

"Oh, shocking!" groaned the Earl.

"Oh, abominable!" growled his Royal Highness.

"What will you take for it?" asked the artist.

"For his nose!" shouted her Grace.

"A thousand pounds," said I, sitting down.

"A thousand pounds?" inquired the artist, musingly.

"A thousand pounds," said I.

"Beautiful!" said he, entranced.

"A thousand pounds," said I.

"Do you warrant it?" he asked, turning the nose to the light.

"I do," said I, blowing it well.

"Is it quite original?" he inquired; touching it with reverence.

"Humph!" said I, twisting it to one side.

"Has *no* copy been taken?" he demanded, surveying it through a microscope.

"None," said I, turning it up.

"Admirable!" he ejaculated, thrown quite off his guard by the beauty of the manoeuvre. ...

LIONIZING
"'Has *no* copy been taken?' he demanded, surveying it through a microscope"

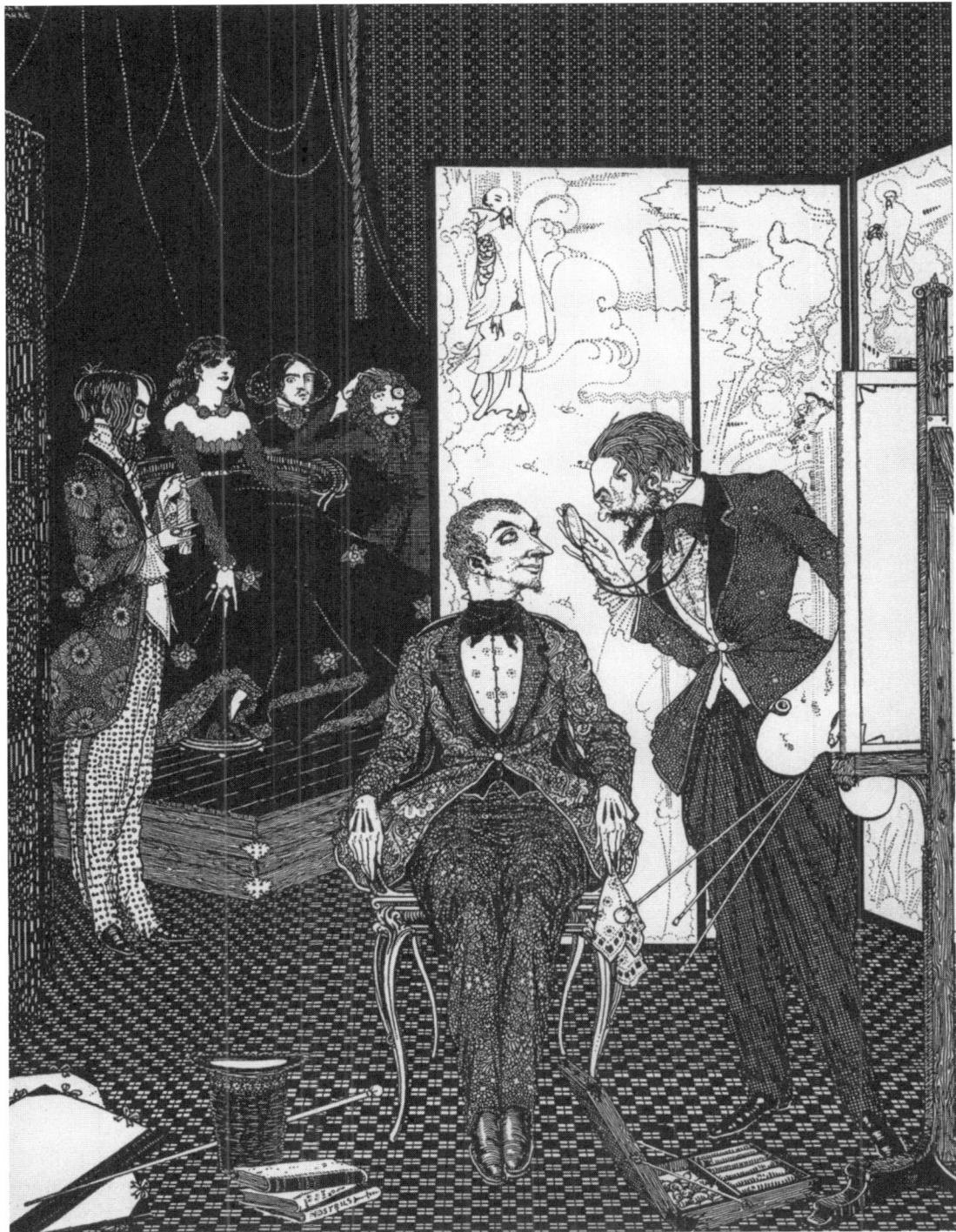

... It was then, however, that the Prince Prospero, maddening with rage and the shame of his own momentary cowardice, rushed hurriedly through the six chambers, while none followed him on account of a deadly terror that had seized upon all. He bore aloft a drawn dagger, and had approached, in rapid impetuosity, to within three or four feet of the retreating figure, when the latter, having attained the extremity of the velvet apartment, turned suddenly and confronted his pursuer. There was a sharp cry – and the dagger dropped gleaming upon the sable carpet, upon which, instantly afterwards, fell prostrate in death the Prince Prospero. Then, summoning the wild courage of despair, a throng of the revellers at once threw themselves into the black apartment, and, seizing the mummer, whose tall figure stood erect and motionless within the shadow of the ebony clock, gasped in unutterable horror at finding the grave-cerements and corpse-like mask which they handled with so violent a rudeness, untenanted by any tangible form.

And now was acknowledged the presence of the Red Death. He had come like a thief in the night. And one by one dropped the revellers in the blood-bedewed halls of their revel, and died each in the despairing posture of his fall. And the life of the ebony clock went out with that of the last of the gay. And the flames of the tripods expired. And Darkness and Decay and the Red Death held illimitable dominion over all.

THE MASQUE OF THE RED DEATH
"The dagger dropped gleaming upon the sable carpet"

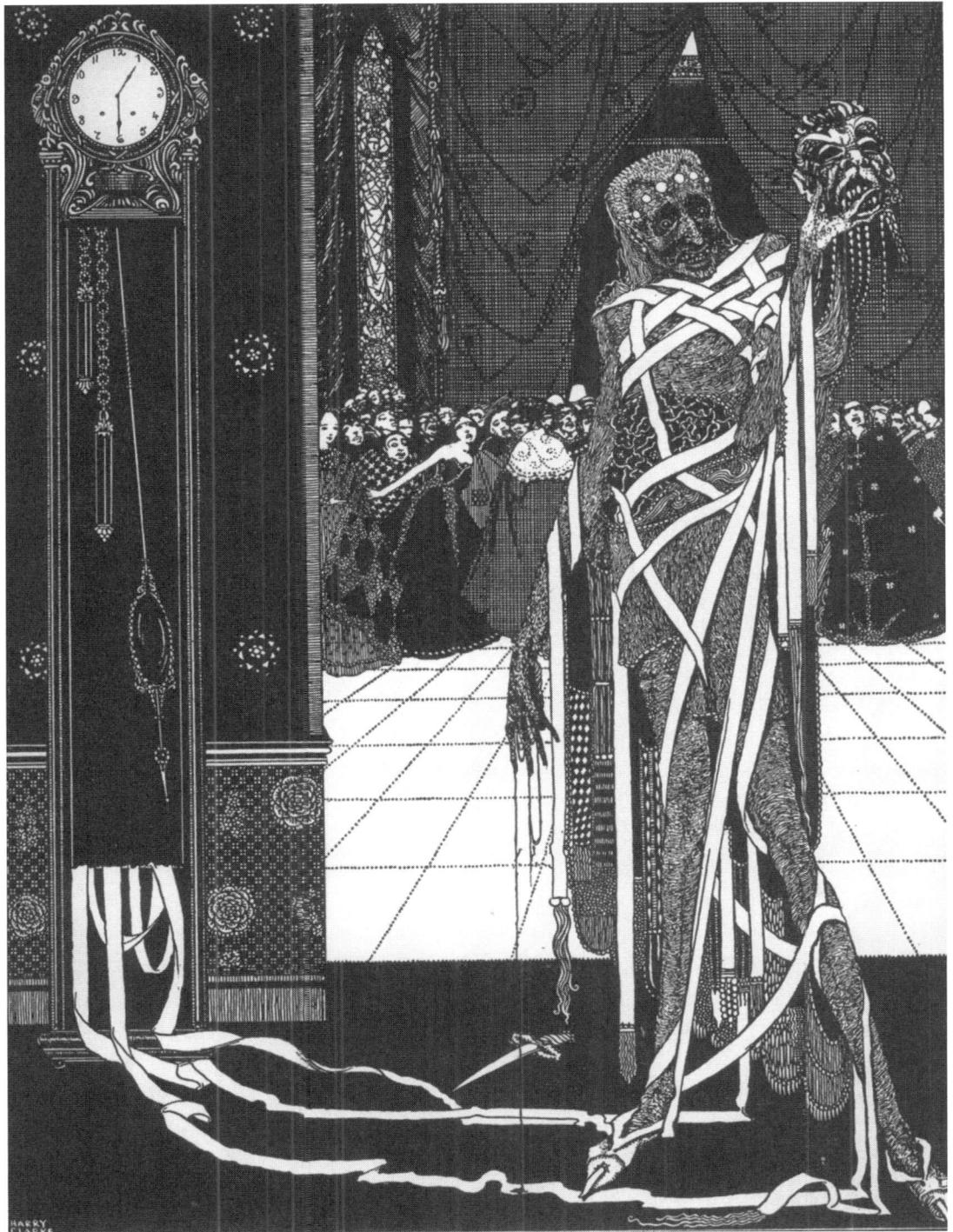

HARRY CLARKE

... Distinct, coldly, calmly distinct, fell those few simple sounds within my ear, and thence like molten lead rolled hissingly into my brain. Years – years may pass away, but the memory of that epoch never. Nor was I indeed ignorant of the flowers and the vine – but the hemlock and the cypress overshadowed me night and day. And I kept no reckoning of time or place, and the stars of my fate faded from heaven, and therefore the earth grew dark, and its figures passed by me like flitting shadows, and among them all I beheld only – Morella. The winds of the firmament breathed but one sound within my ears, and the ripples upon the sea murmured evermore – Morella. But she died; and with my own hands I bore her to the tomb; and I laughed with a long and bitter laugh as I found no traces of the first in the channel where I laid the second – Morella.

MORELLA
"The earth grew dark, and its figures passed me by, like flitting shadows, and among them all I beheld only – Morella"

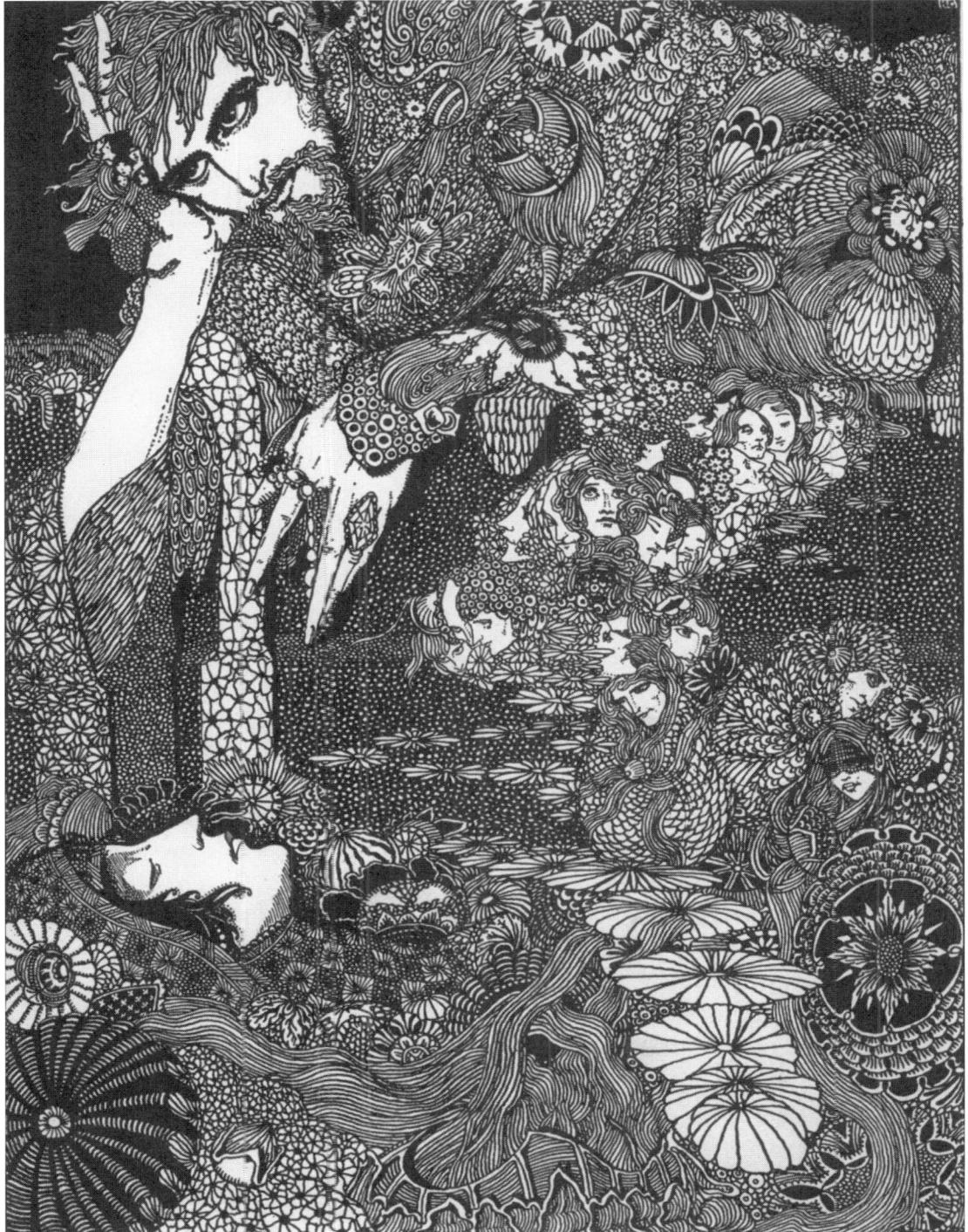

... It is long since I first trod the deck of this terrible ship, and the rays of my destiny are, I think, gathering to a focus. Incomprehensible men! Wrapped up in meditations of a kind which I cannot divine, they pass me by unnoticed. Concealment is utter folly on my part, for the people will not see. It was but just now that I passed directly before the eyes of the mate – it was no long while ago that I ventured into the captain's own private cabin, and took thence the materials with which I write, and have written. I shall from time to time continue this Journal. It is true that I may not find an opportunity of transmitting it to the world, but I will not fail to make the endeavour. At the last moment I will enclose the MS. in a bottle, and cast it within the sea. ...

MS FOUND IN A BOTTLE
"Incomprehensible men! Wrapped up in meditations of a kind which I cannot divine, they pass me by unnoticed"

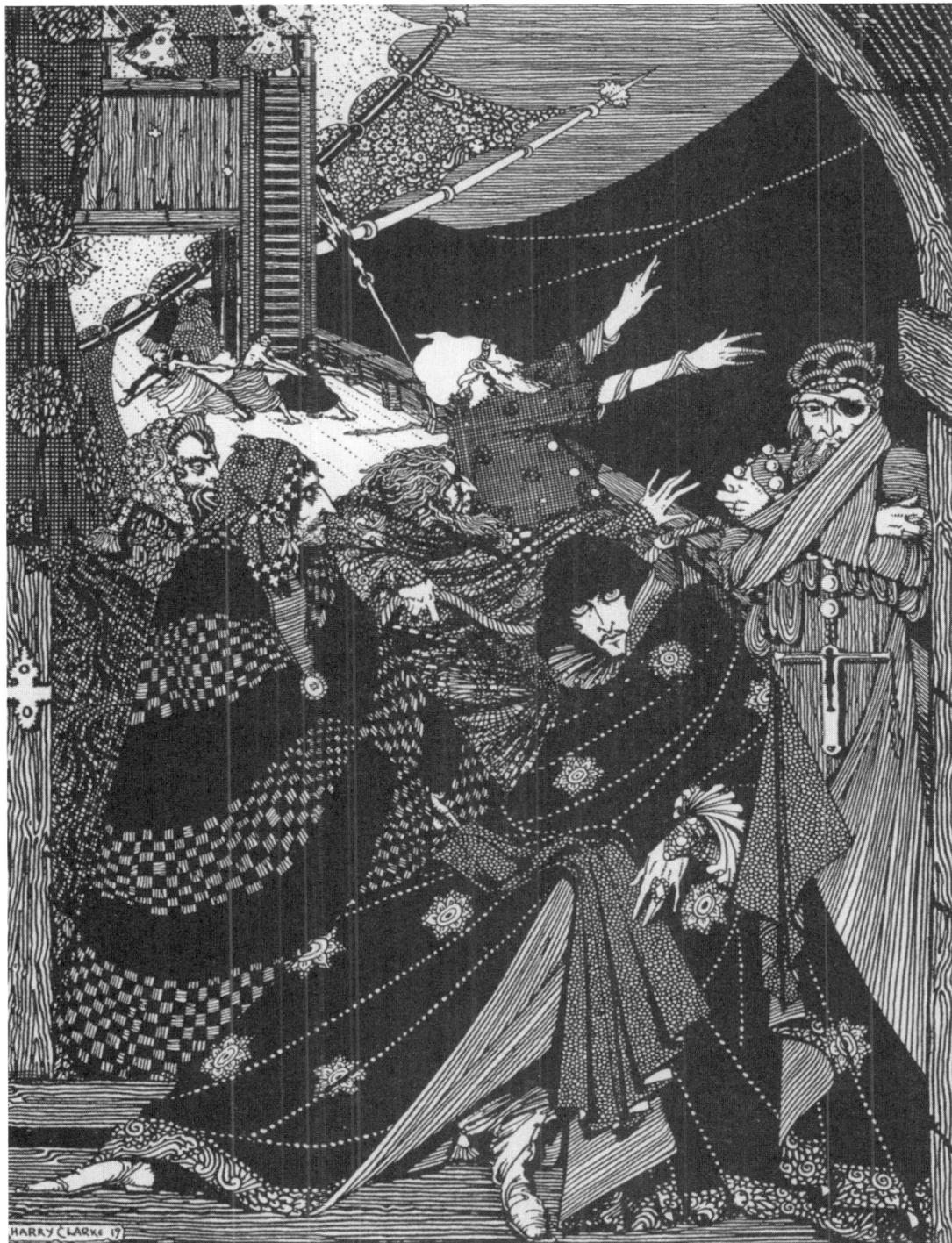

HARRY CLARKE 19

... As the sailor looked in, the gigantic animal had seized Madame L'Espanaye by the hair, (which was loose, as she had been combing it,) and was flourishing the razor about her face, in imitation of the motions of a barber. The daughter lay prostrate and motionless; she had swooned. The screams and struggles of the old lady (during which the hair was torn from her head) had the effect of changing the probably pacific purposes of the Ourang-Outang into those of wrath. With one determined sweep of its muscular arm it nearly severed her head from her body. The sight of blood inflamed its anger into phrenzy. Gnashing its teeth, and flashing fire from its eyes, it flew upon the body of the girl, and imbedded its fearful talons in her throat, retaining its grasp until she expired. Its wandering and wild glances fell at this moment upon the head of the bed, over which the face of its master, rigid with horror, was just discernible. The fury of the beast, who no doubt bore still in mind the dreaded whip, was instantly converted into fear. Conscious of having deserved punishment, it seemed desirous of concealing its bloody deeds, and skipped about the chamber in an agony of nervous agitation; throwing down and breaking the furniture as it moved, and dragging the bed from the bedstead. In conclusion, it seized first the corpse of the daughter, and thrust it up the chimney, as it was found; then that of the old lady, which it immediately hurled through the window headlong. ...

THE MURDERS IN THE RUE MORGUE
"Gnashing its teeth, and flashing fire from its eyes, it flew upon the body of the girl"

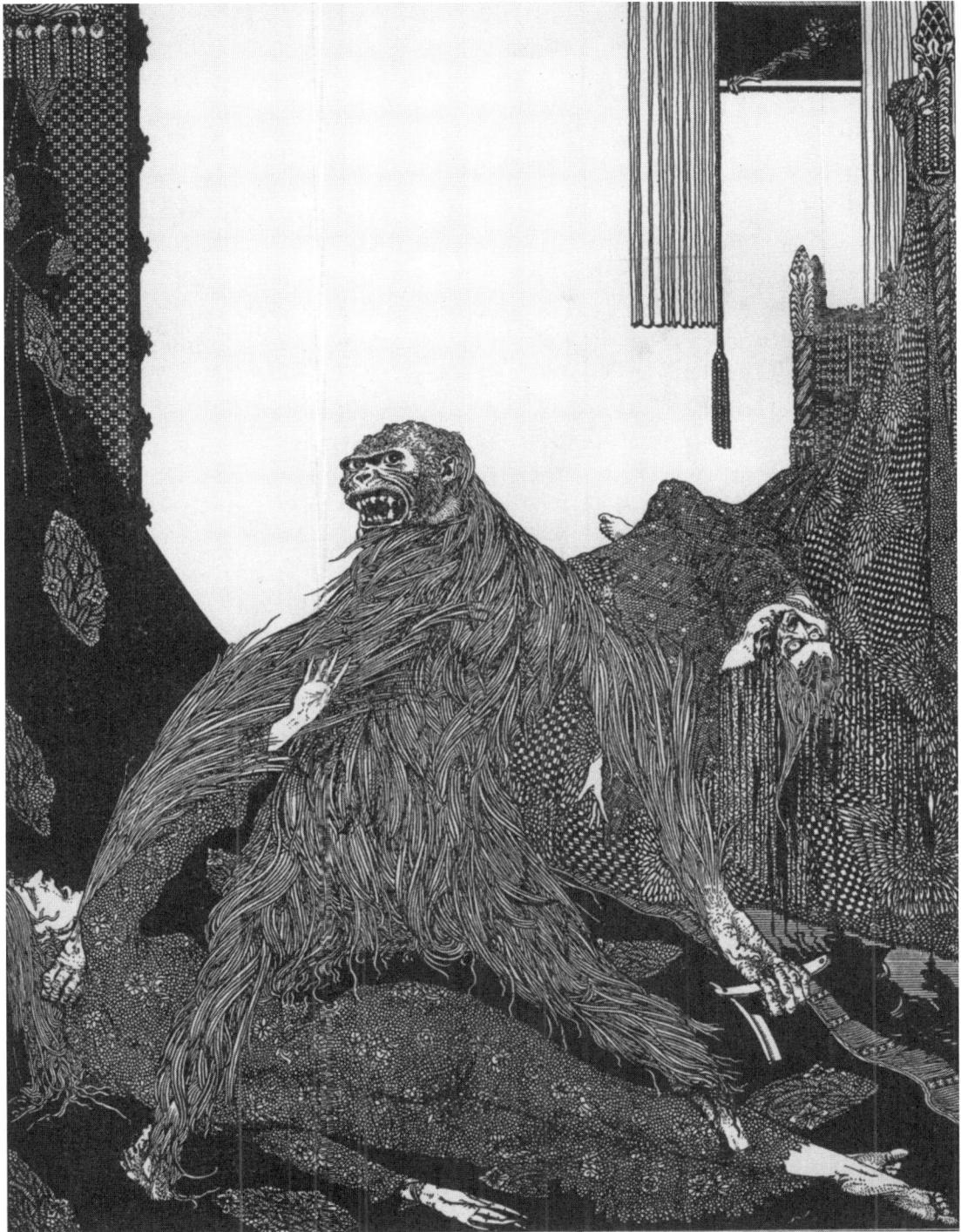

... "An individual has committed the murder. He is alone with the ghost of the departed. He is appalled by what lies motionless before him. The fury of his passion is over, and there is abundant room in his heart for the natural awe of the deed. His is none of that confidence which the presence of numbers inevitably inspires. He is alone with the dead. He trembles and is bewildered. Yet there is a necessity for disposing of the corpse. He bears it to the river, but leaves behind him the other evidences of guilt; for it is difficult, if not impossible to carry all the burthen at once, and it will be easy to return for what is left. But in his toilsome journey to the water his fears redouble within him. The sounds of life encompass his path. A dozen times he hears or fancies the step of an observer. Even the very lights from the city bewilder him. Yet, in time and by long and frequent pauses of deep agony, he reaches the river's brink, and disposes of his ghastly charge – perhaps through the medium of a boat. But now what treasure does the world hold – what threat of vengeance could it hold out – which would have power to urge the return of that lonely murderer over that toilsome and perilous path, to the thicket and its blood chilling recollections? He returns not, let the consequences be what they may. He could not return if he would. His sole thought is immediate escape. He turns his back forever upon those dreadful shrubberies and flees as from the wrath to come." ...

<div style="text-align: right">

THE MYSTERY OF MARIE ROGÊT
"In his toilsome journey to the water his fears redouble within him"

</div>

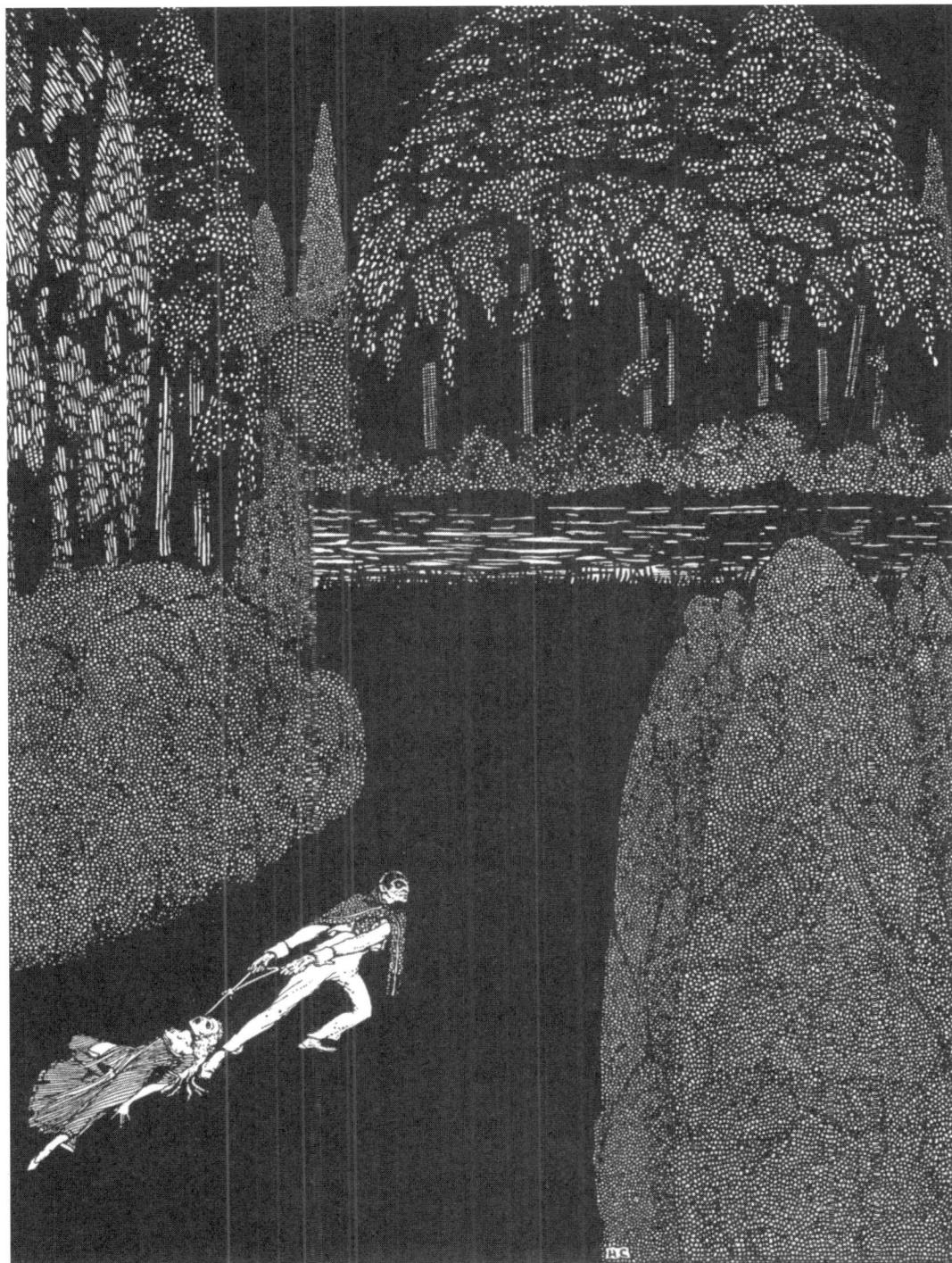

I WAS sick – sick unto death with that long agony; and when they at length unbound me, and I was permitted to sit, I felt that my senses were leaving me. The sentence – the dread sentence of death – was the last of distinct accentuation which reached my ears. After that, the sound of the inquisitorial voices seemed merged in one dreamy indeterminate hum. It conveyed to my soul the idea of revolution--perhaps from its association in fancy with the burr of a mill wheel. This only for a brief period; for presently I heard no more. Yet, for a while, I saw; but with how terrible an exaggeration! I saw the lips of the black-robed judges. They appeared to me white – whiter than the sheet upon which I trace these words – and thin even to grotesqueness; thin with the intensity of their expression of firmness – of immoveable resolution – of stern contempt of human torture. I saw that the decrees of what to me was Fate, were still issuing from those lips. I saw them writhe with a deadly locution. I saw them fashion the syllables of my name; and I shuddered because no sound succeeded. I saw, too, for a few moments of delirious horror, the soft and nearly imperceptible waving of the sable draperies which enwrapped the walls of the apartment. And then my vision fell upon the seven tall candles upon the table. At first they wore the aspect of charity, and seemed white and slender angels who would save me; but then, all at once, there came a most deadly nausea over my spirit, and I felt every fibre in my frame thrill as if I had touched the wire of a galvanic battery, while the angel forms became meaningless spectres, with heads of flame, and I saw that from them there would be no help. And then there stole into my fancy, like a rich musical note, the thought of what sweet rest there must be in the grave. The thought came gently and stealthily, and it seemed long before it attained full appreciation; but just as my spirit came at length properly to feel and entertain it, the figures of the judges vanished, as if magically, from before me; the tall candles sank into nothingness; their flames went out utterly; the blackness of darkness supervened; all sensations appeared swallowed up in a mad rushing descent as of the soul into Hades. Then silence, and stillness, night were the universe. ...

THE PIT AND THE PENDULUM
"I saw them fashion the syllables of my name"

60

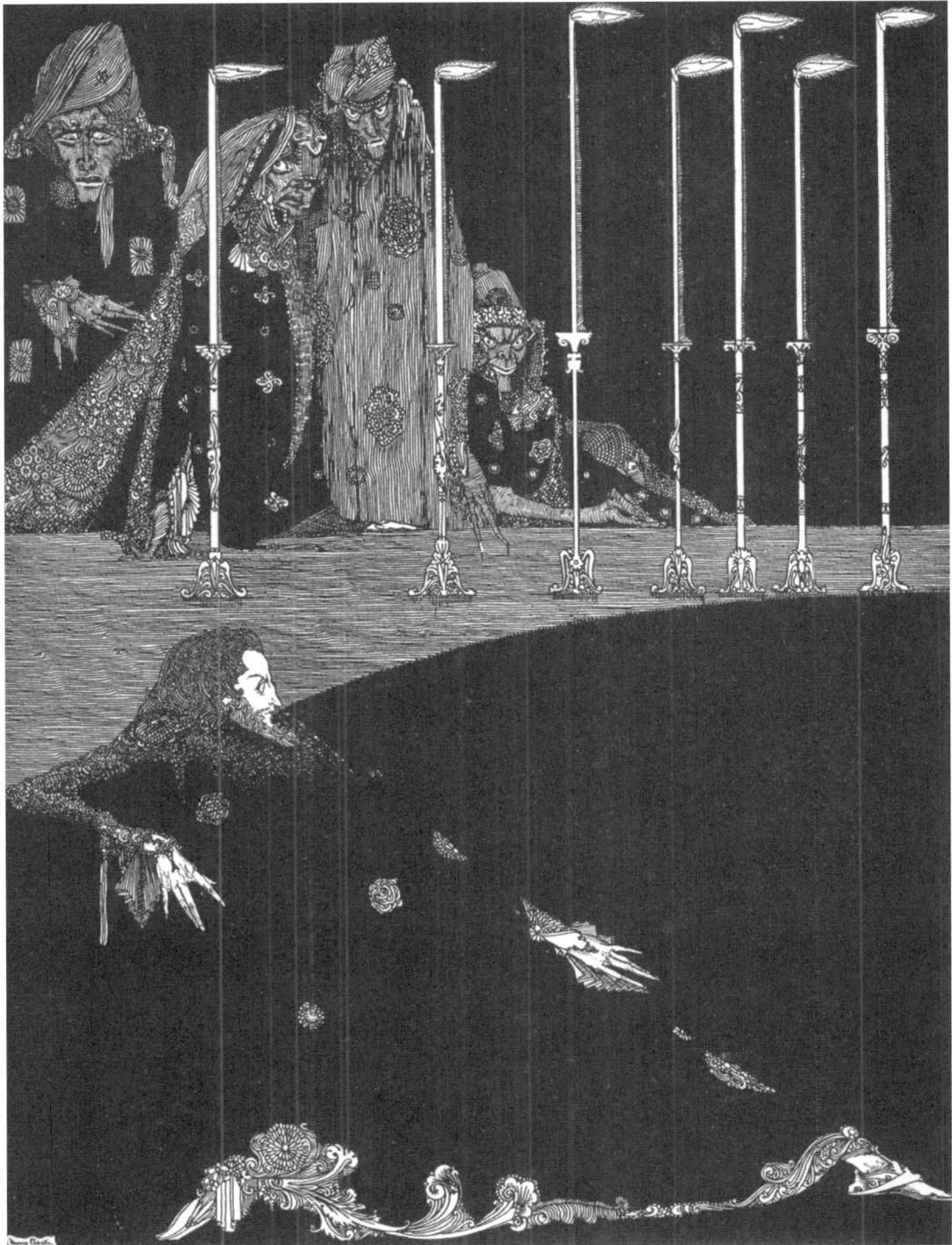

... At first the ravenous animals were startled and terrified at the change – at the cessation of movement. They shrank alarmedly back; many sought the well. But this was only for a moment. I had not counted in vain upon their voracity. Observing that I remained without motion, one or two of the boldest leaped upon the frame-work, and smelt at the surcingle. This seemed the signal for a general rush. Forth from the well they hurried in fresh troops. They clung to the wood – they overran it, and leaped in hundreds upon my person. The measured movement of the pendulum disturbed them not at all. Avoiding its strokes they busied themselves with the anointed bandage. They pressed – they swarmed upon me in ever accumulating heaps. They writhed upon my throat; their cold lips sought my own; I was half stifled by their thronging pressure; disgust, for which the world has no name. swelled my bosom. and chilled, with a heavy clamminess, my heart. Yet one minute, and I felt that the struggle would be over. Plainly I perceived the loosening of the bandage. I knew that in more than one place it must be already severed. With a more than human resolution I lay still. ...

THE PIT AND THE PENDULUM
"They swarmed upon me in ever-accumulating heaps"

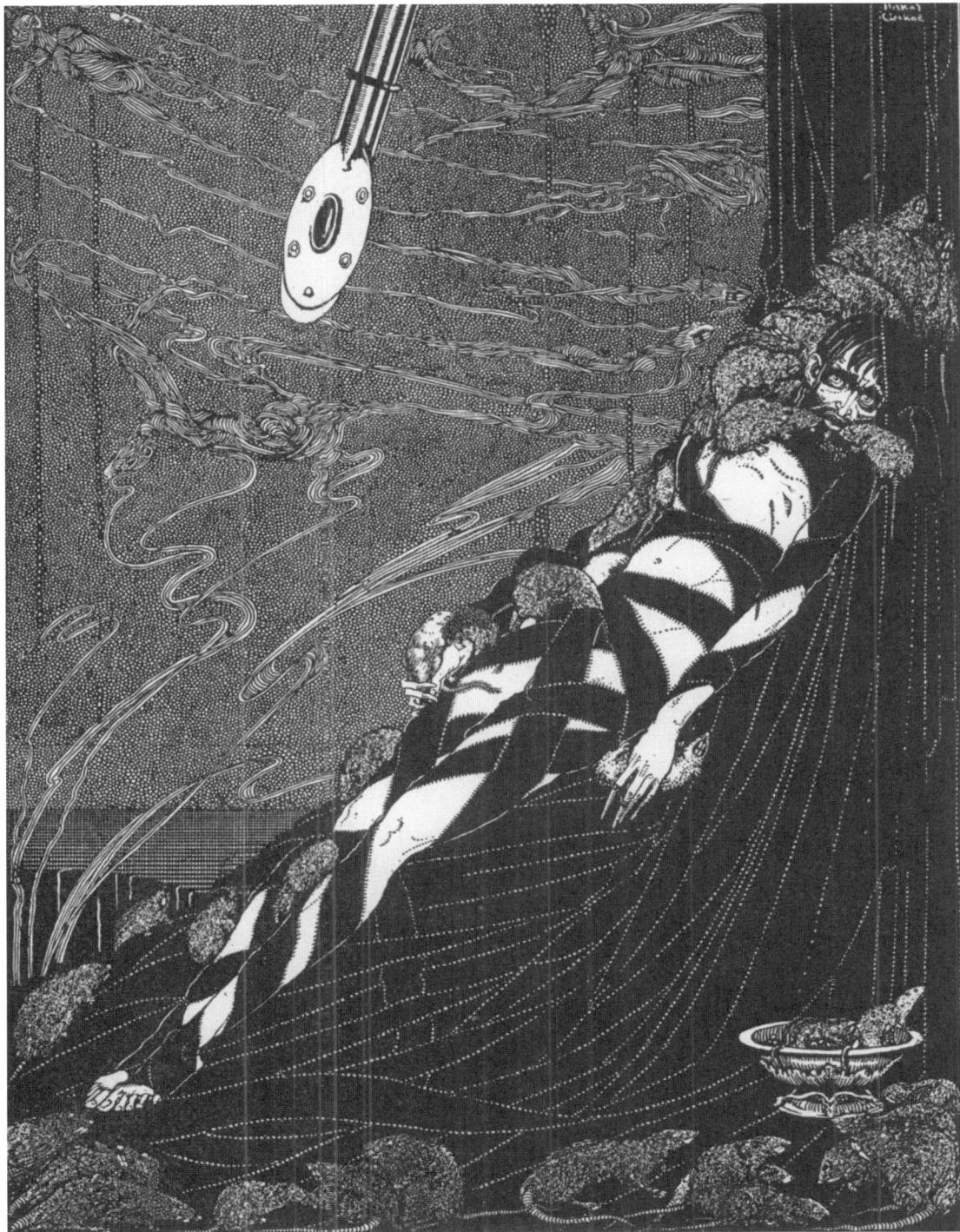

... The movement of the jaws, in this effort to cry aloud, showed me that they were bound up, as is usual with the dead. I felt, too, that I lay upon some hard substance, and by something similar my sides were, also, closely compressed. So far, I had not ventured to stir any of my limbs--but now I violently threw up my arms, which had been lying at length, with the wrists crossed. They struck a solid wooden substance, which extended above my person at an elevation of not more than six inches from my face. I could no longer doubt that I reposed within a coffin at last.

And now, amid all my infinite miseries, came sweetly the cherub Hope – for I thought of my precautions. I writhed, and made spasmodic exertions to force open the lid: it would not move. I felt my wrists for the bell-rope: it was not to be found. And now the Comforter fled for ever, and a still sterner Despair reigned triumphant; for I could not help perceiving the absence of the paddings which I had so carefully prepared – and then, too, there came suddenly to my nostrils the strong peculiar odor of moist earth. The conclusion was irresistible. I was not within the vault. I had fallen into a trance while absent from home – while among strangers – when, or how, I could not remember – and it was they who had buried me as a dog – nailed up in some common coffin – and thrust deep, deep, and for ever, into some ordinary and nameless *grave*. ...

THE PREMATURE BURIAL
"Deep, deep, and forever, into some ordinary and nameless *grave*"

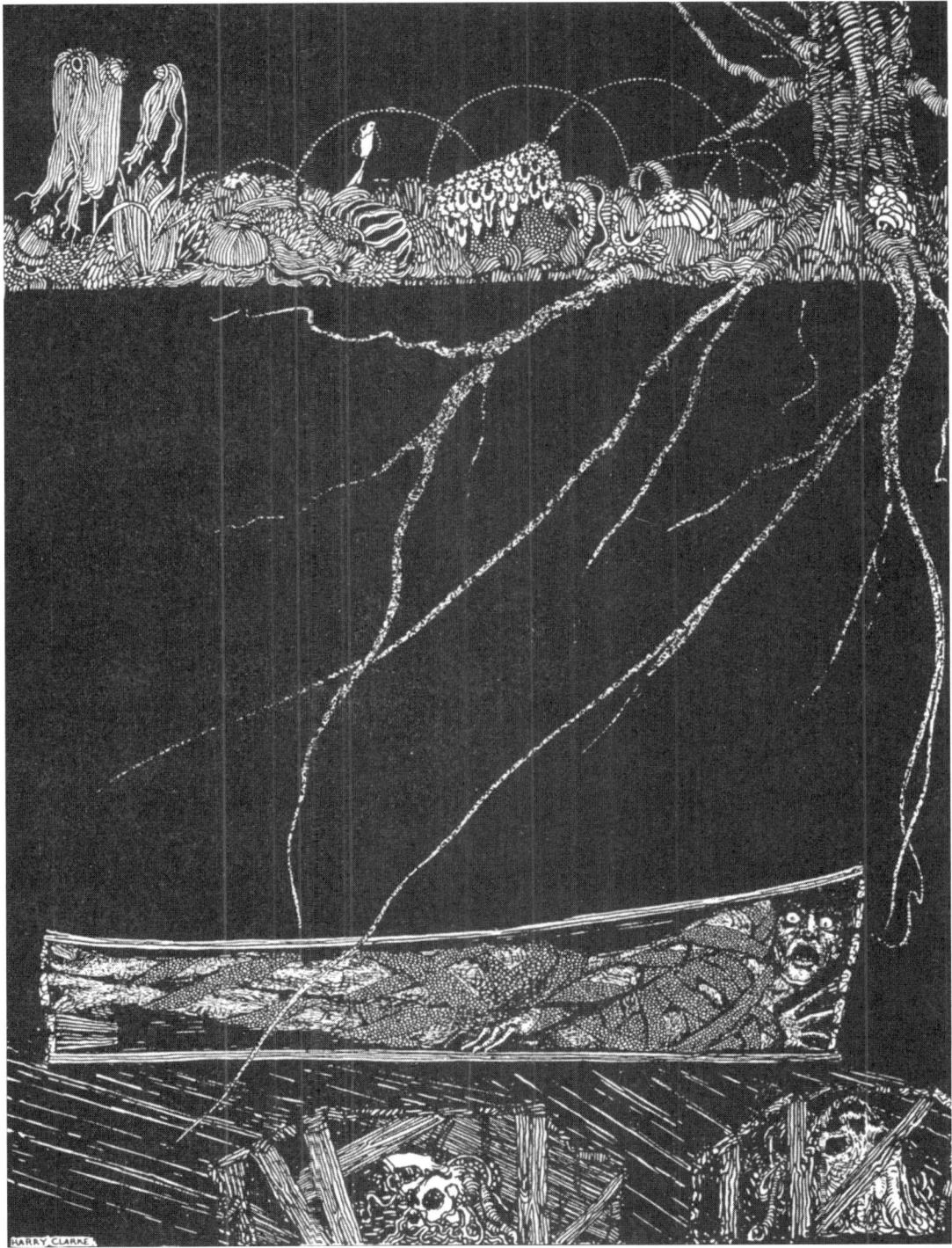

HARRY CLARKE

... "And mine eyes fell upon the countenance of the man, and his countenance was wan with terror. And, hurriedly, he raised his head from his hand, and stood forth upon the rock and listened. But there was no voice throughout the vast illimitable desert, and the characters upon the rock were SILENCE. And the man shuddered, and turned his face away, and fled afar off, in haste, so that I beheld him no more."

Now there are fine tales in the volumes of the Magi – in the iron-bound, melancholy volumes of the Magi. Therein, I say, are glorious histories of the Heaven, and of the Earth, and of the mighty sea – and of the Genii that over-ruled the sea, and the earth, and the lofty heaven. There was much lore too in the sayings which were said by the Sybils; and holy, holy things were heard of old by the dim leaves that trembled around Dodon – but, as Allah liveth, that fable which the Demon told me as he sat by my side in the shadow of the tomb, I hold to be the most wonderful of all! And as the Demon made an end of his story, he fell back within the cavity of the tomb and laughed. And I could not laugh with the Demon, and he cursed me because I could not laugh. And the lynx which dwelleth forever in the tomb, came out therefrom, and lay down at the feet of the Demon, and looked at him steadily in the face.

SILENCE – A FABLE
"But there was no voice throughout the vast, illimitable desert"

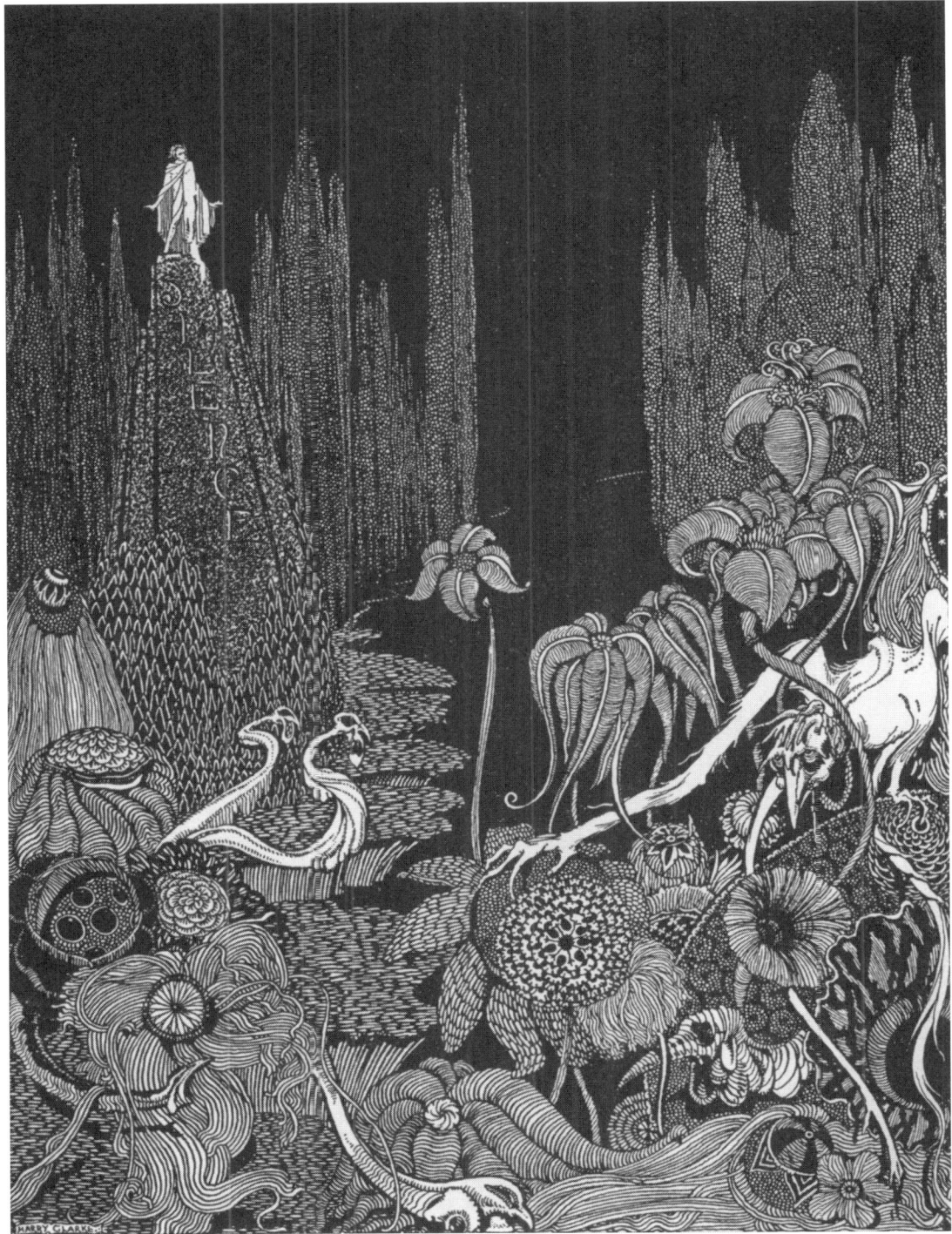

... But even yet I refrained and kept still. I scarcely breathed. I held the lantern motionless. I tried how steadily I could maintain the ray upon the eye. Meantime the hellish tattoo of the heart increased. It grew quicker and quicker, and louder and louder every instant. The old man's terror must have been extreme! It grew louder, I say, louder every moment! – do you mark me well I have told you that I am nervous: so I am. And now at the dead hour of the night, amid the dreadful silence of that old house, so strange a noise as this excited me to uncontrollable terror. Yet, for some minutes longer I refrained and stood still. But the beating grew louder, louder! I thought the heart must burst. And now a new anxiety seized me – the sound would be heard by a neighbour! The old man's hour had come! With a loud yell, I threw open the lantern and leaped into the room. He shrieked once – once only. In an instant I dragged him to the floor, and pulled the heavy bed over him. I then smiled gaily, to find the deed so far done. But, for many minutes, the heart beat on with a muffled sound. This, however, did not vex me; it would not be heard through the wall. At length it ceased. The old man was dead. I removed the bed and examined the corpse. Yes, he was stone, stone dead. I placed my hand upon the heart and held it there many minutes. There was no pulsation. He was stone dead. His eye would trouble me no more. ...

THE TELL-TALE HEART
"But, for many minutes, the heart beat on with a muffled sound"

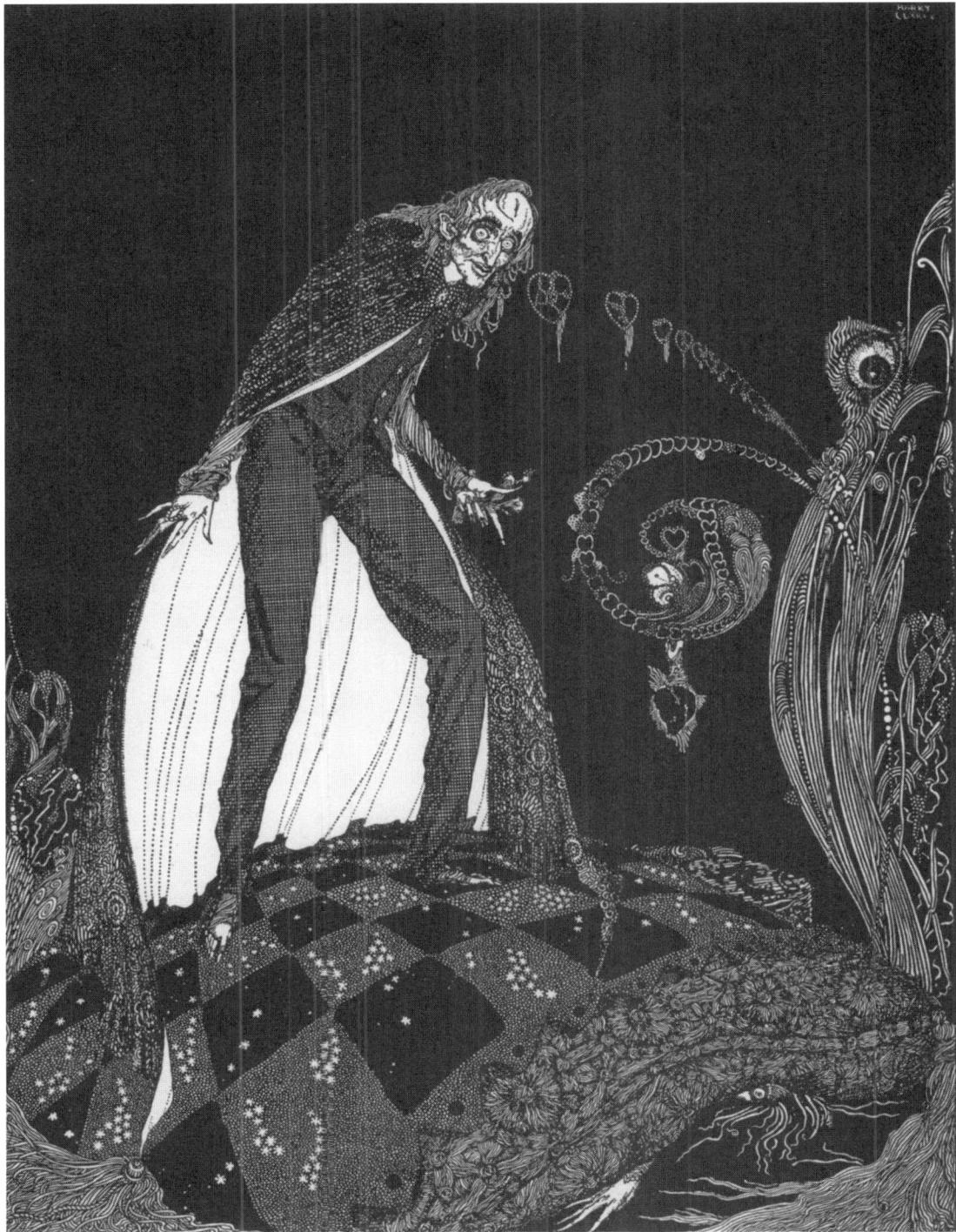

... At that instant some person tried the latch of the door. I hastened to prevent an intrusion, and then immediately returned to my dying antagonist. But what human language can adequately portray that astonishment, that horror which possessed me at the spectacle then presented to view? The brief moment in which I averted my eyes had been sufficient to produce, apparently, a material change in the arrangements at the upper or farther end of the room. A large mirror, – so at first it seemed to me in my confusion – now stood where none had been perceptible before; and, as I stepped up to it in extremity of terror, mine own image, but with features all pale and dabbled in blood, advanced to meet me with a feeble and tottering gait.

Thus it appeared, I say, but was not. It was my antagonist – it was Wilson, who then stood before me in the agonies of his dissolution. His mask and cloak lay, where he had thrown them, upon the floor. Not a thread in all his raiment – not a line in all the marked and singular lineaments of his face which was not, even in the most absolute identity, mine own!

It was Wilson; but he spoke no longer in a whisper, and I could have fancied that I myself was speaking while he said:

"You have conquered, and I yield. Yet, henceforward art thou also dead – dead to the World, to Heaven and to Hope! In me didst thou exist – and, in my death, see by this image, which is thine own, how utterly thou hast murdered thyself."

WILLIAM WILSON
"In my death, see by this image, which is thine own, how utterly thou hast murdered thyself"

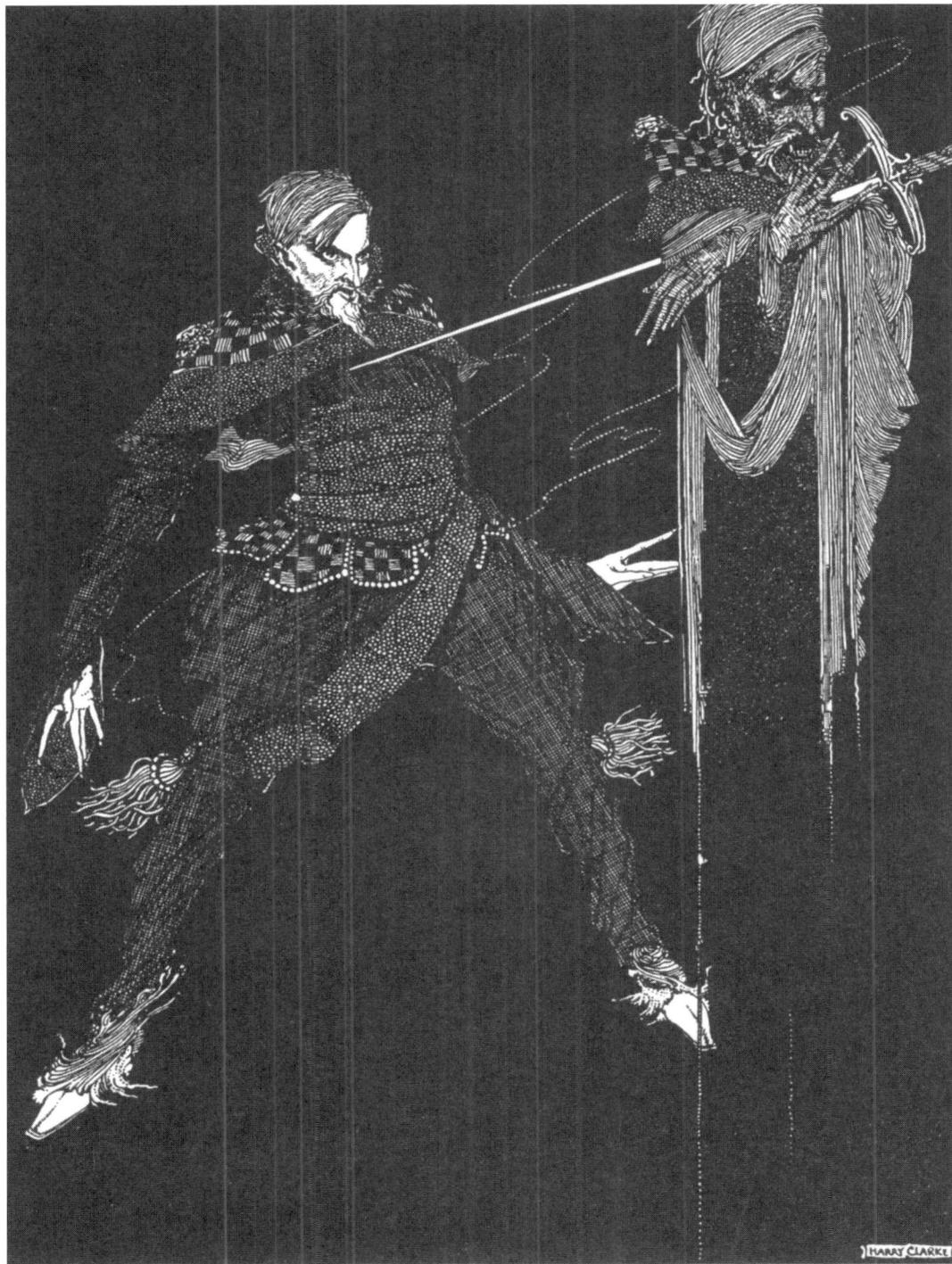

HARRY CLARKE

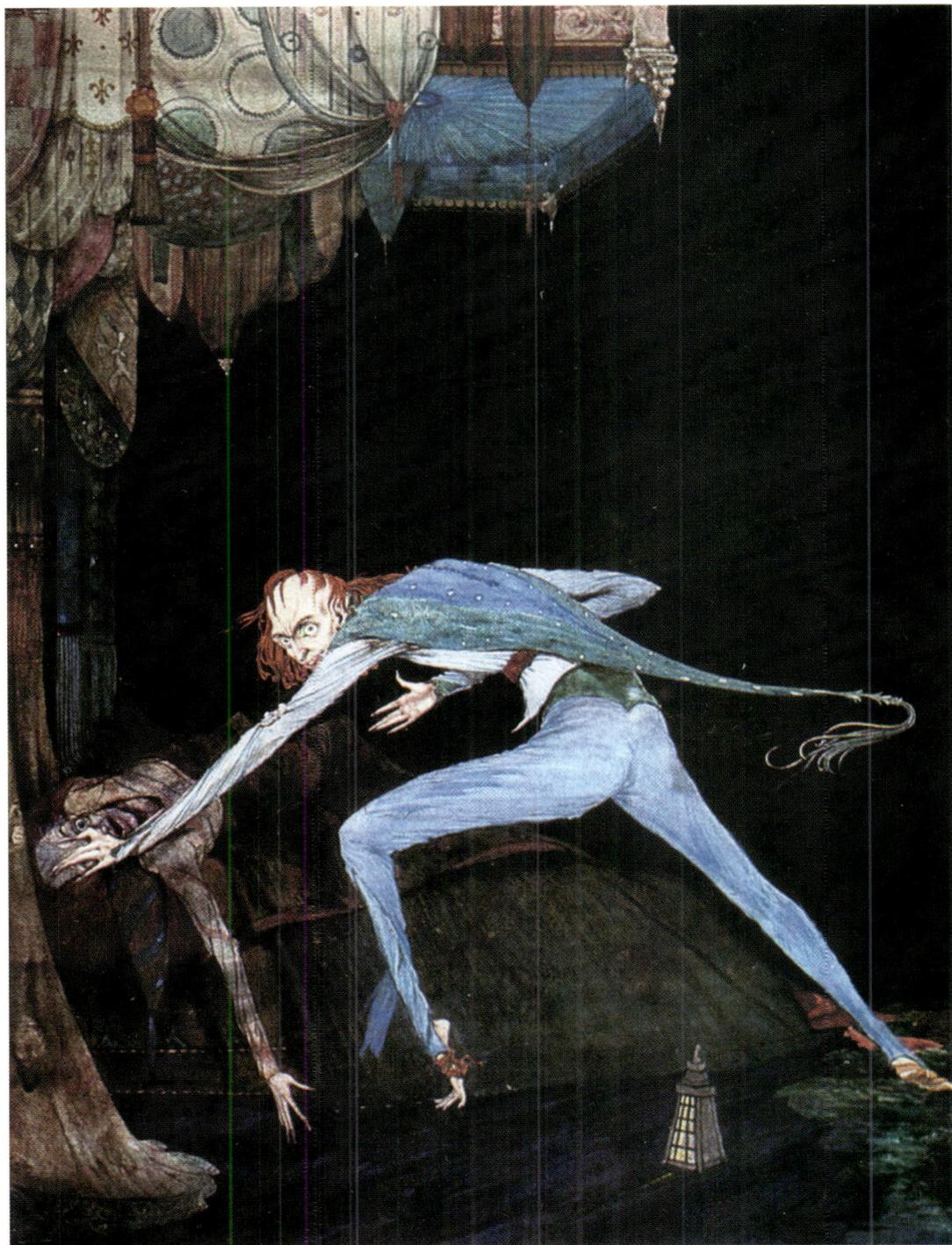

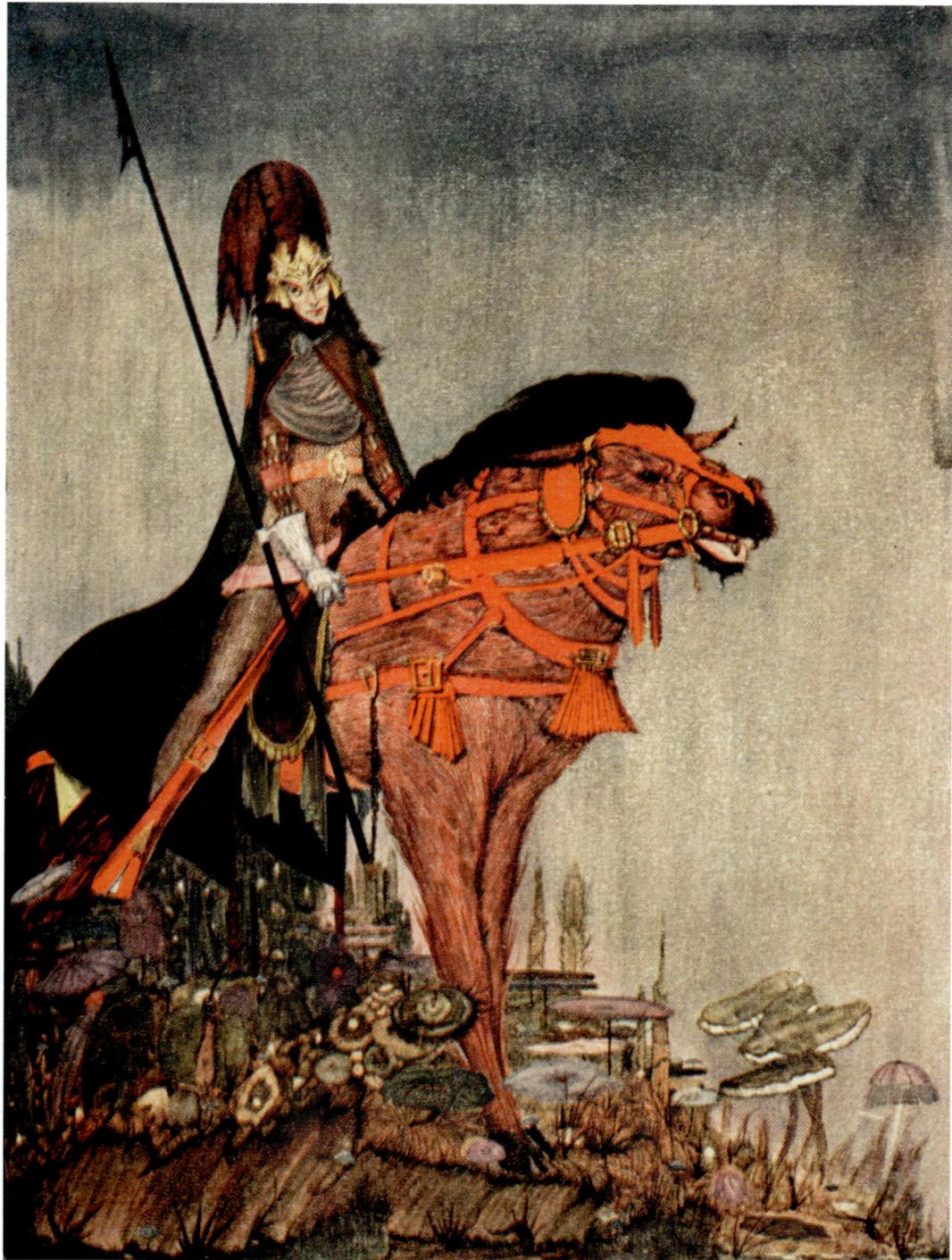

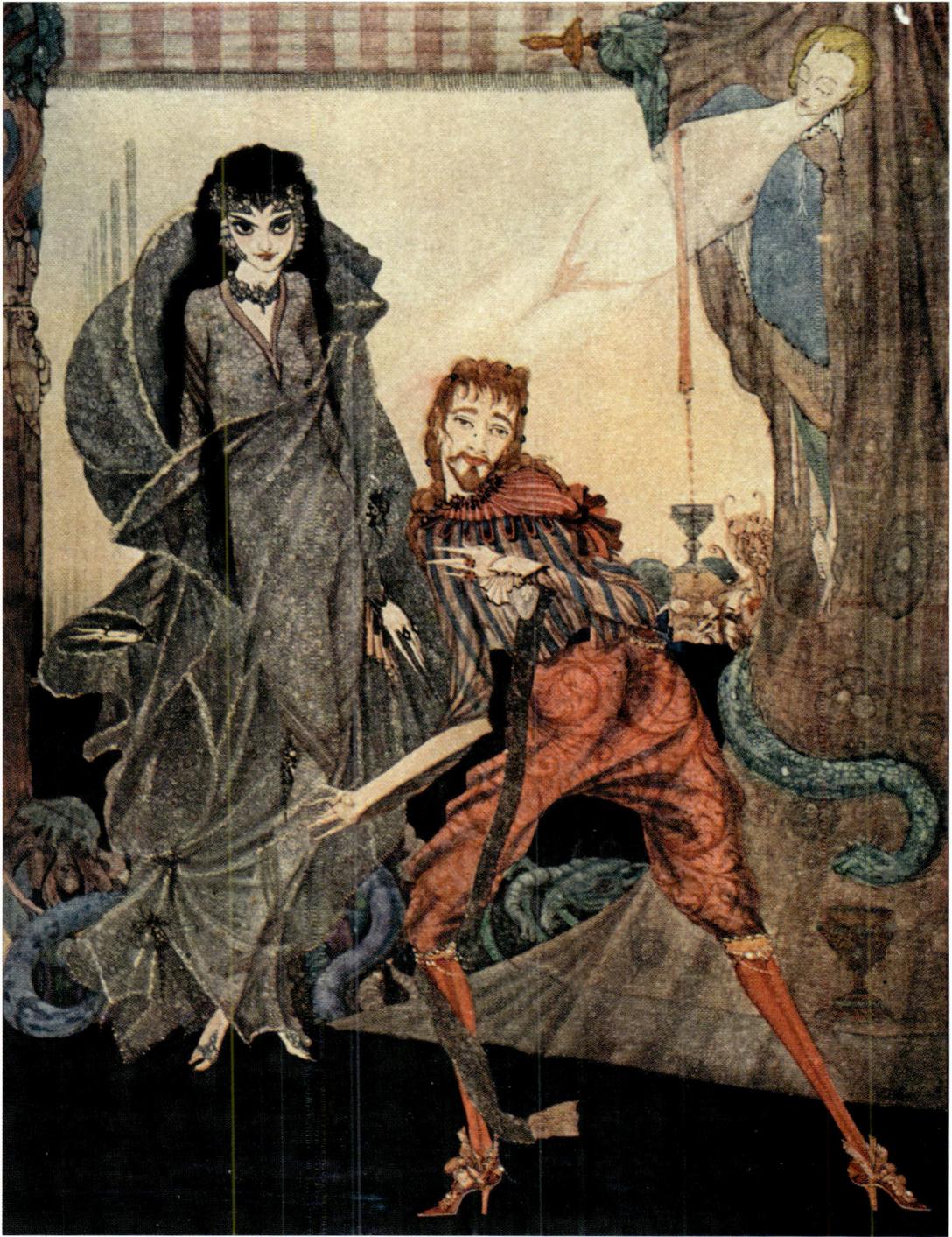

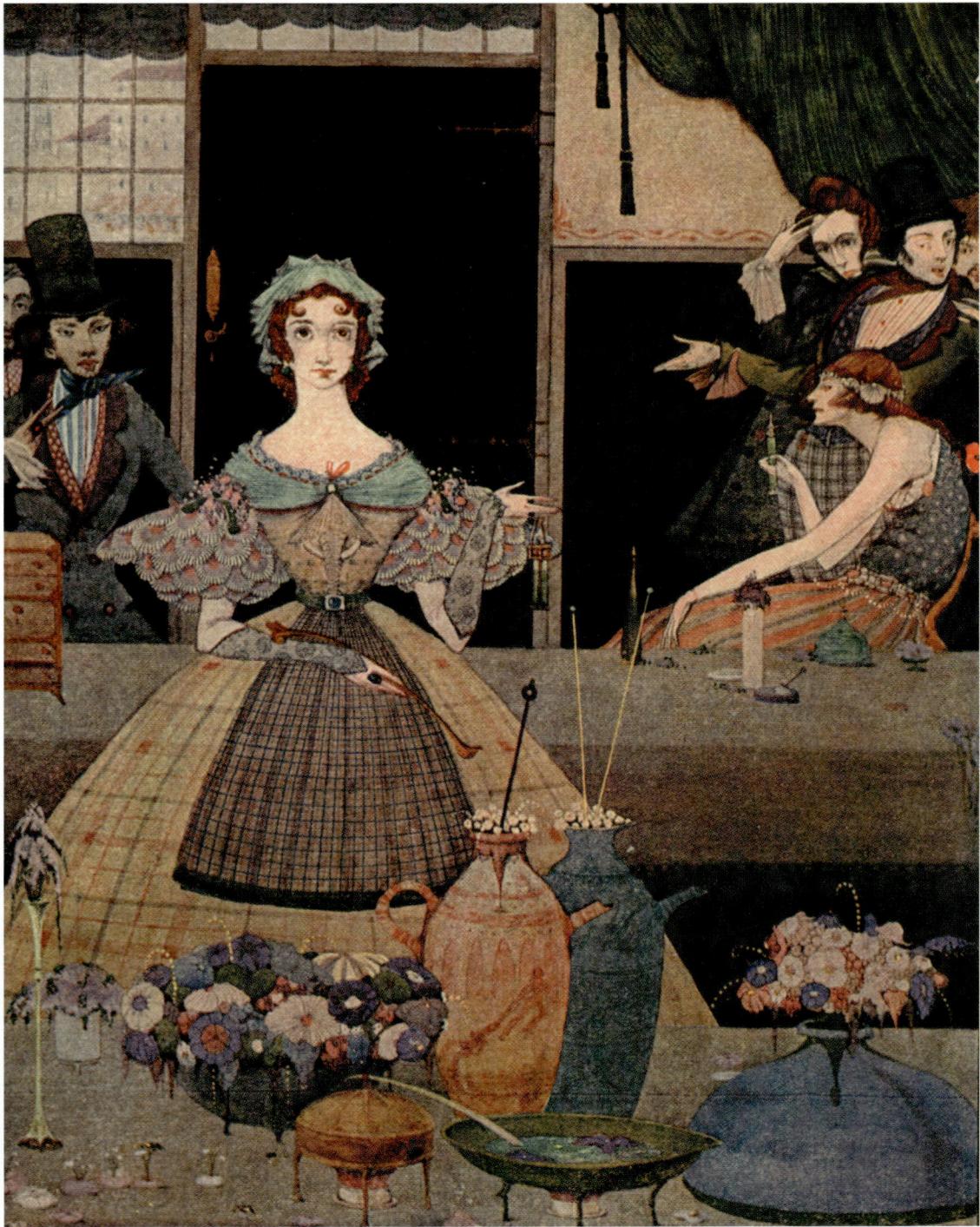

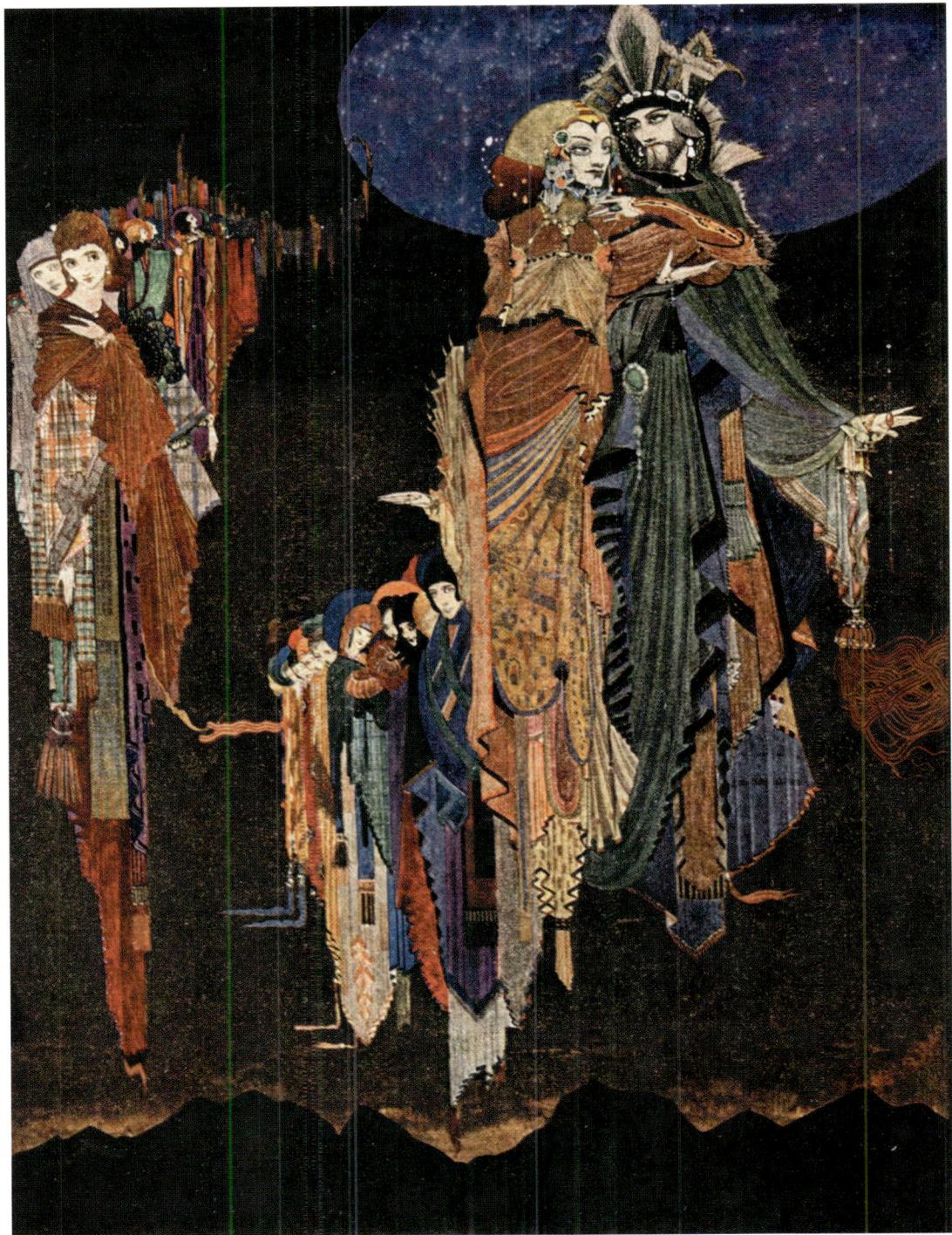

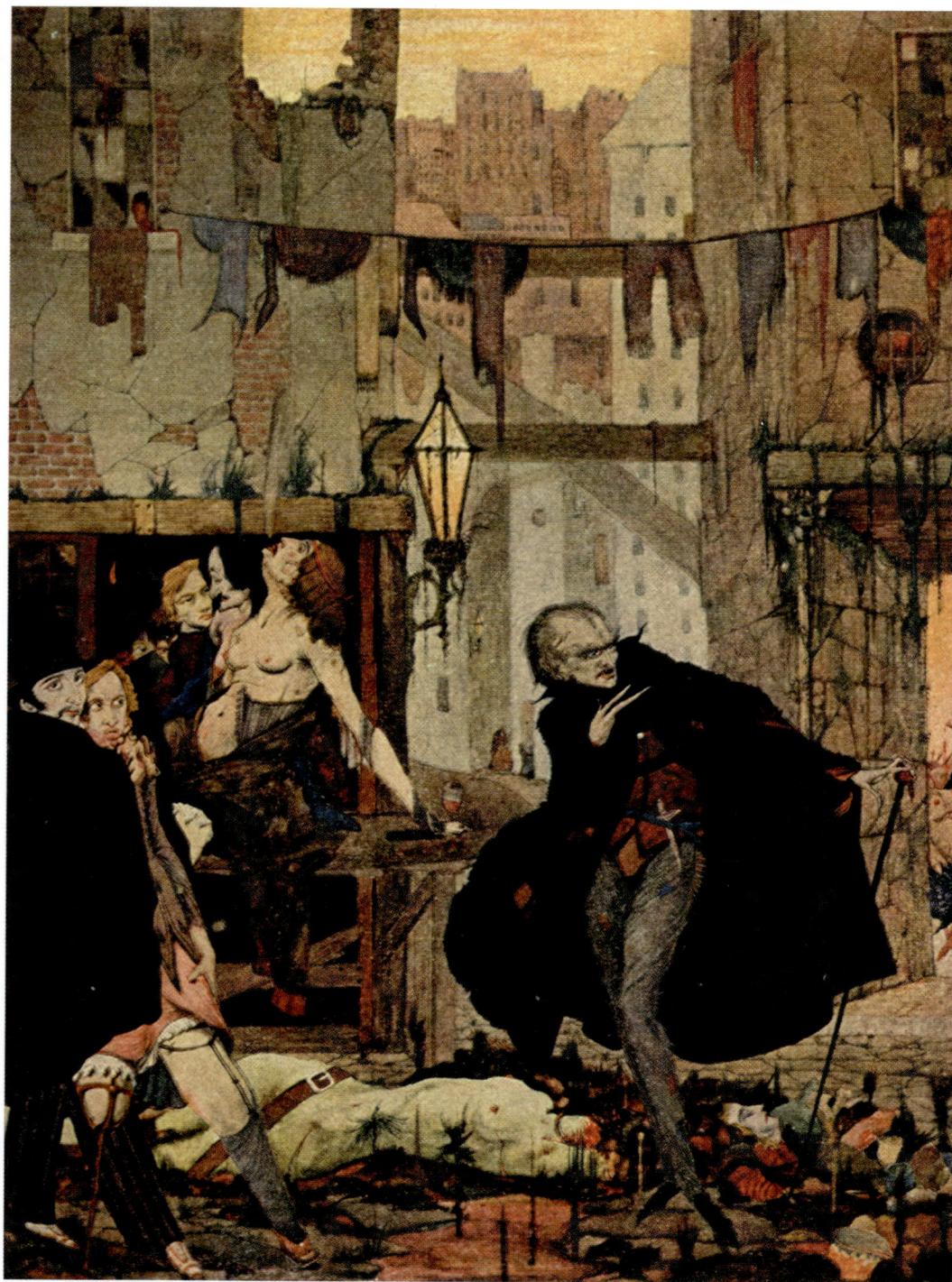

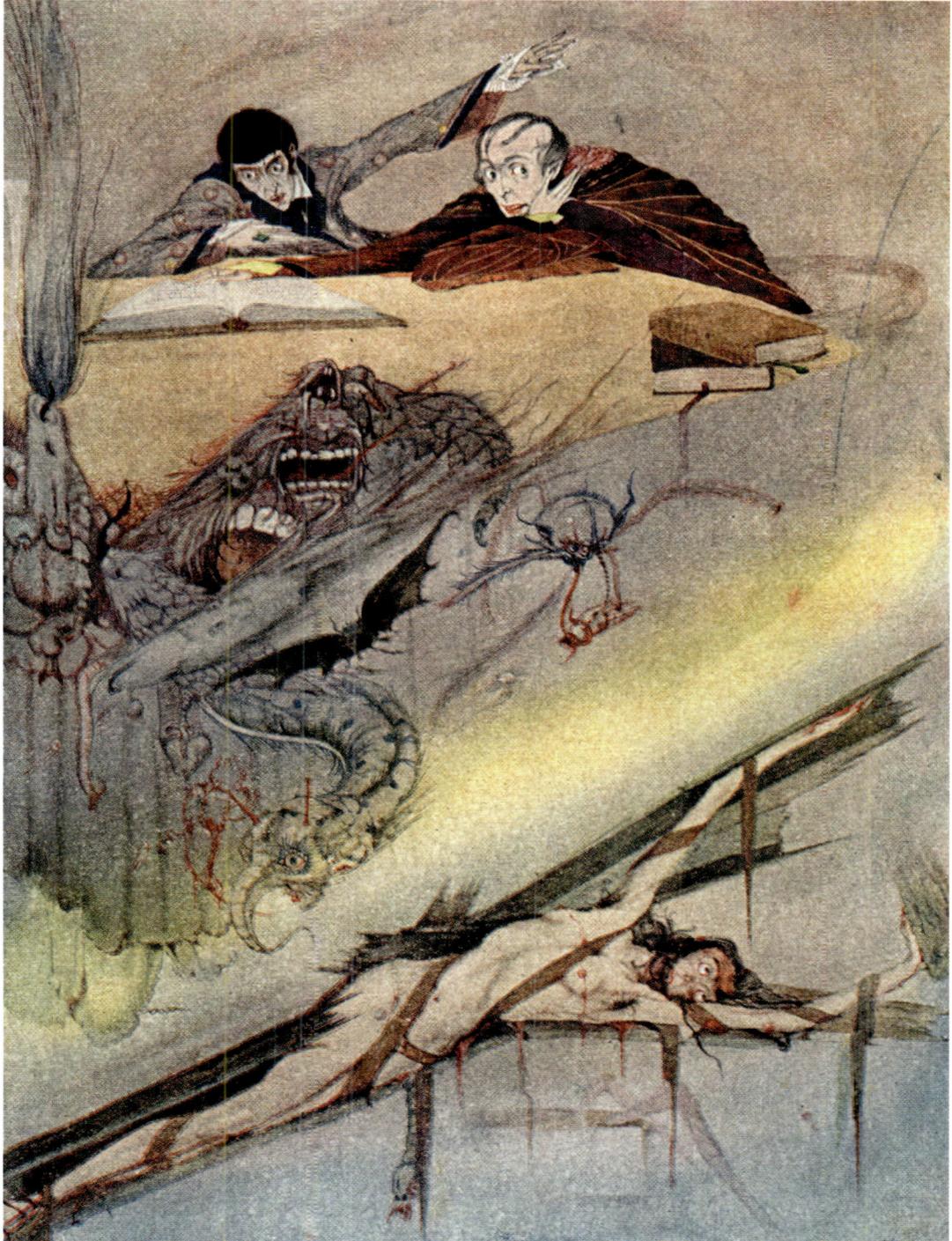

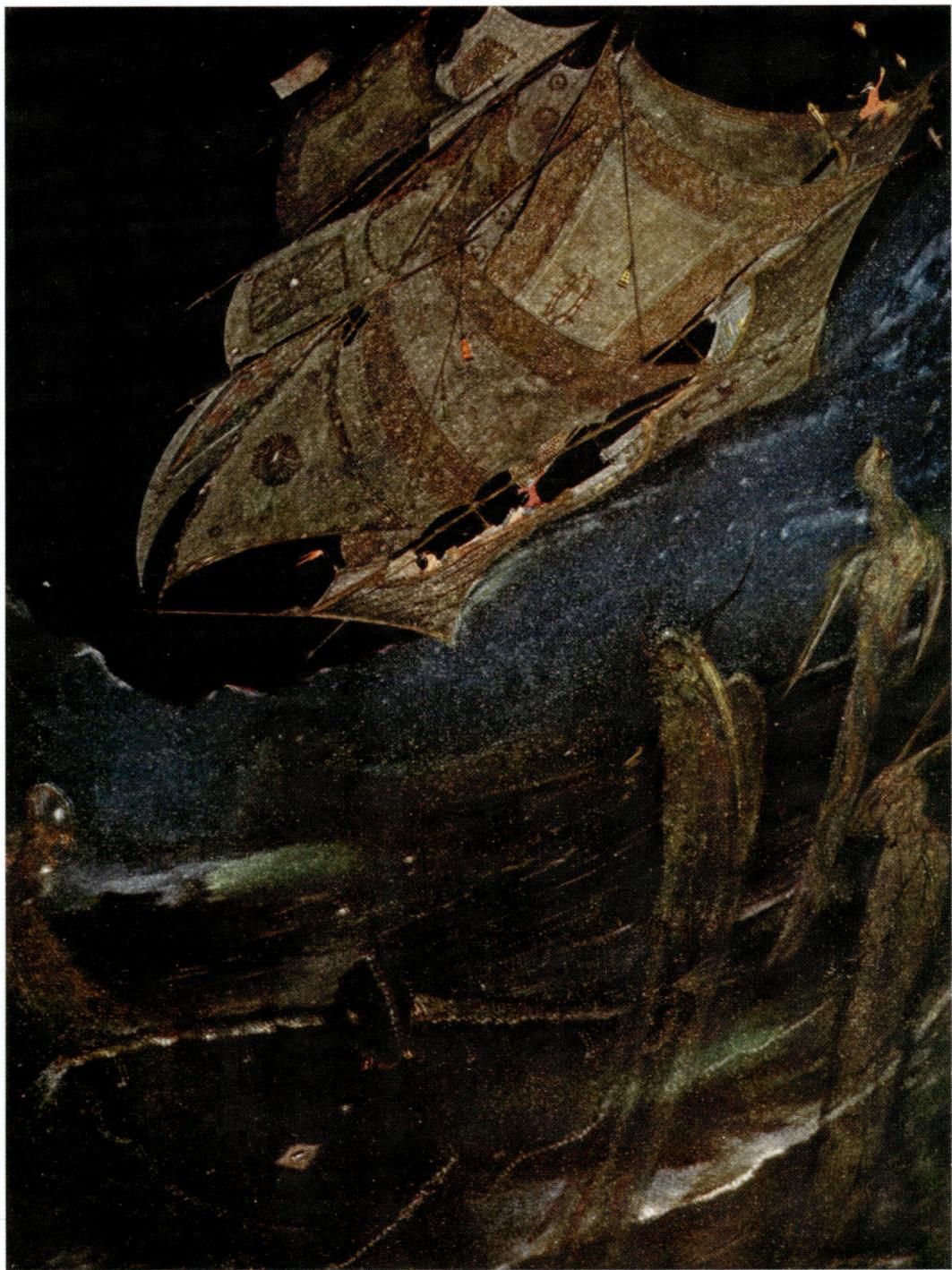

Tailpieces from Edgar Allan Poe's
TALES OF MYSTERY AND IMAGINATION

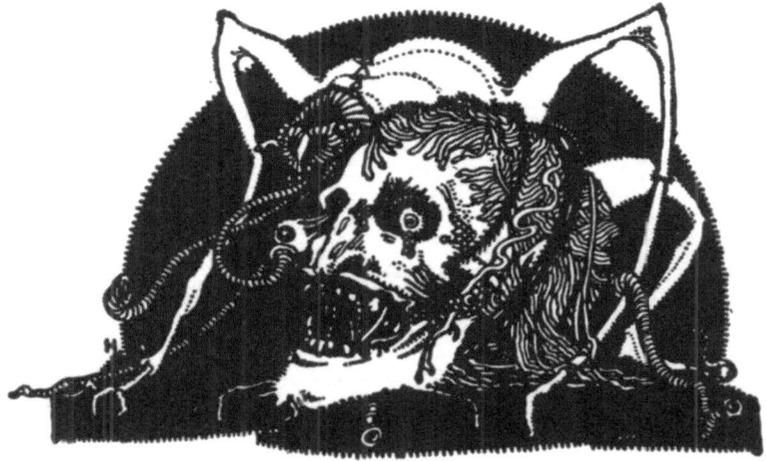

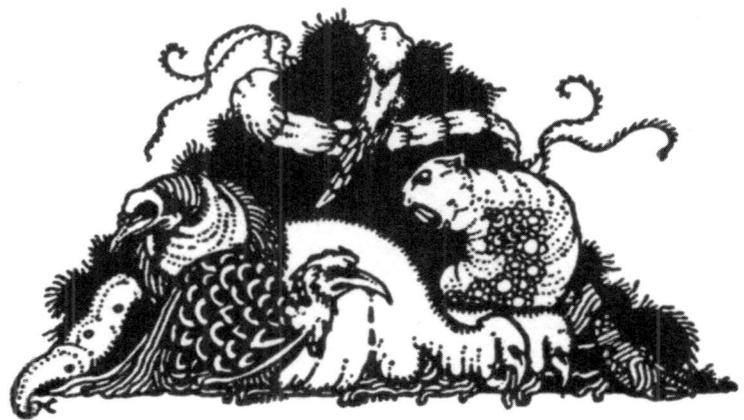

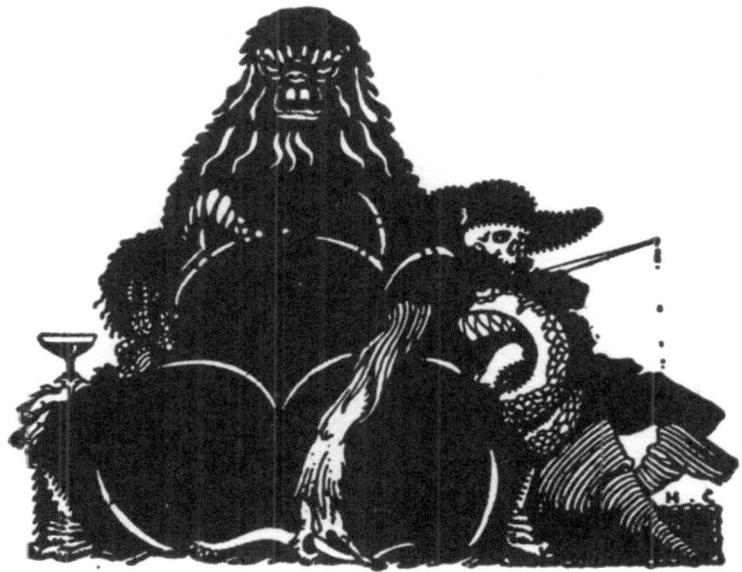

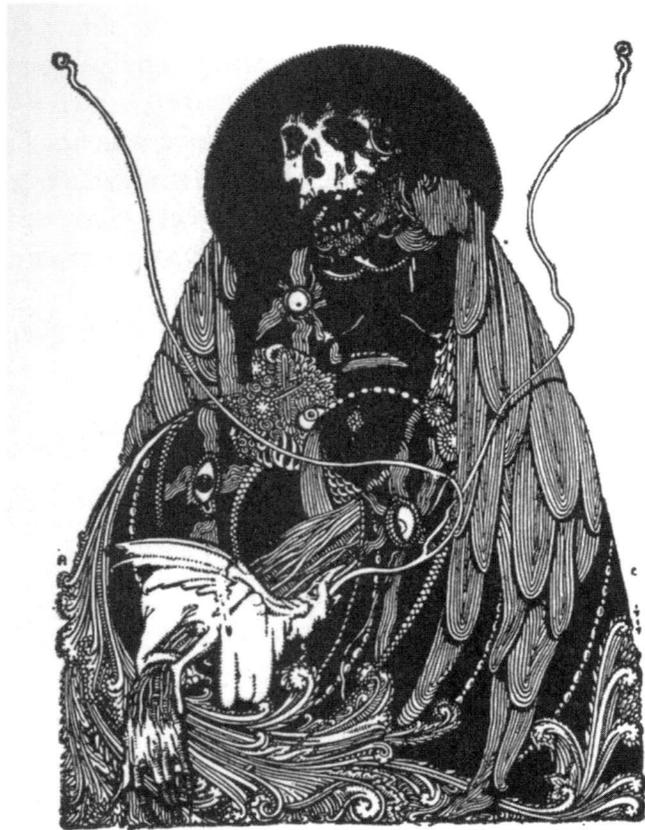